PRINTING TYPES

PRINTING

TYPES

An Introduction

Revised and Expanded Edition

Alexander S. Lawson
with
Dwight Agner

Beacon Press Boston

Beacon Press
25 Beacon Street
Boston, Massachusetts 02108–2800

Beacon Press books
are published under the auspices of
the Unitarian Universalist Association of Congregations.

97 96 95 94 93 92 91 90 8 7 6 5 4 3 2 1

Library of Congress Cataloging-in-Publication Data
Lawson, Alexander S.
 Printing types : an introduction / Alexander S. Lawson with Dwight Agner. —
Rev. and expanded ed.
 p. cm.
 Includes bibliographical references.
 ISBN 0–8070–6661–3
 1. Type and type-founding. I. Agner, Dwight. II. Title.
Z250.L35 1990
686.2'24—dc20 89–46056

Contents

Foreword

The first edition of this book was written in 1970 to supplement a course in the development of printing types which I taught in the School of Printing at Rochester Institute of Technology. I was convinced then as I am now that the simplest method of learning to recognize the almost overwhelming number of printing types in use by American printers was to group them in a logical system based first upon their structure and secondly upon their historic derivation.

The intent of the course was not just to train typographic specialists but also to aid the majority of my students who were primarily attracted to careers in printing management. Certainly printing executives should be knowledgeable about type, a basic element of their profession.

Since the publication of the book an enormous transition has occurred in the field of typographic composition. Hot metal typesetting, while even then starting to give way to the impact of photographic processes, still remained dominant. Presently phototypesetting itself has become subordinate to computerized procedures; the manufacture of printing types has likewise undergone a transformation prompted by digital technology. However, just as the first successful automation of typesetting in the 1880s resulted in no fundamental changes in typographic morphology, the current modification of a traditional craft will have little effect upon the basic roman letterforms which have been in use for the past five centuries.

Thus, while revision of this text includes discussion of the technological advances instrumental to current printing types, the classification system of identification remains central to the achievement of that goal.

I continue to rely upon the editorial assistance of my wife Eve-

lyn and for the suggestions of Professor Archie Provan at RIT. I
am also indebted to Dwight Agner, a former student who has re-
mained a warm friend some twenty-five years out of the class-
room, and who is now a typographer of wide experience daily
involved in current typographic technology. While his specific
contribution has been the section on computerized typesetting he
has made numerous suggestions for updating the entire text. Fi-
nally, I would like to thank Pam Pokorney, of the Beacon Press
staff, whose enthusiasm for the book has resulted in the present
revision.

PRINTING TYPES

1
History and Development of Typesetting

Historical Development—1440–1885

This book is primarily a guide to the recognition of printing types transferred to a printed surface by any process. To many typographers, however, recognition of the printed image alone is not sufficient; they rightly also wish to investigate the traditions affecting the development of printing types over the entire period of their existence.

Johann Gutenberg of Mainz, Germany, is credited by most historians with the invention of movable types about 1440. While prior to the Gutenberg era Chinese clay letters had been used as early as the eleventh century, and bronze types had been cast in Korea about 1403, these developments had not been widely disseminated in the West.

Gutenberg's contribution, it may be noted, was not the type itself, but the adjustable mold by which it could be cast. The original mold was in approximately the same form still presently used for hand-casting; that is, a device containing dimensions of height, length, and width, which cast a character in relief (see figure 1.).

For almost four and a half centuries, the procedures of manufacturing type changed very little, although the design on the face underwent an astonishing variety of mutations. The first step in the manufacture of a type was traditionally the cutting of a bar of steel called a punch, which contained a character engraved upon its end. (See figure 2.) Briefly, this operation began with scratching a letterform in reverse on the punch blank, a bar

1. *Hand mold*

of soft steel. A second punch, called a counterpunch, was pre-
pared to create the sunken portion of the letter formed by driving
it into the punch blank itself. The balance of the character was
then filed by hand until the letter was formed. Finishing touches
were made with a graver, a more precise tool than a file.

During this involved operation, the punchcutter could check
his progress by blackening the face of the letter over a flame and
pressing the punch into paper to obtain a smoke proof. The com-
pleted punch was then hardened to enable it to withstand nu-
merous impressions into a bar of copper or brass to strike, or
drive, a matrix from which type could be cast. (See figure 3.)

The matrix was then placed in the mold and held in position
with a spring clamp, whereupon the typecaster (a craftsman em-
ployed exclusively for this operation) held the mold in one hand
and poured into it a ladle of molten metal, at the same time jerk-
ing the mold upward to force the metal into the matrix. The mold
was opened up, and the piece of type removed to undergo sev-
eral finishing steps, called dressing. In this step the jet was re-
moved from the bottom and any flash or burrs at the sides
rubbed off. A groove was then planed into the bottom of the let-
ter, smoothing the jet break and supplying "feet" upon which the
letter would stand. Hand casting produced from 2,000 to 4,000
characters a day, depending on the skill of the typecaster. (See
figure 4.)

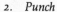

2. *Punch* 3. *Matrix*

The cutting of punches was a separate and highly regarded employment, superior to that of casting the type. For a hundred years after Gutenberg both these crafts were practiced in the individual printing office. But about the middle of the sixteenth century, they were the first specialty skills to break away from the printing office when typefoundries were set up to service many printers from one source.

The first technological improvement in founding type occurred in Philadelphia in 1811 when Archibald Binny, of the firm of Binny and Ronaldson—America's first successful typefounders—invented a spring lever for the mold which doubled its production. This innovation was followed by a pivotal typecasting machine invented by David Bruce of New York in 1838, (figure 5). The Bruce casting device had a capacity of some 3,000 12-point types per hour and was the principal casting machine in use in the United States until the 1880s. Then several high-speed power operated casters were marketed. Although the manufacture of single types is no longer a flourishing business, these later casting machines, with but few modifications, continue to be used. It is probable that for the needs of smaller printing establishments, private presses, and amateur printers, most single types are presently being cast on Monotype machines, which are described below.

The dependence upon hand punchcutting lasted somewhat longer. It was not until 1885 that Linn Boyd Benton, an American

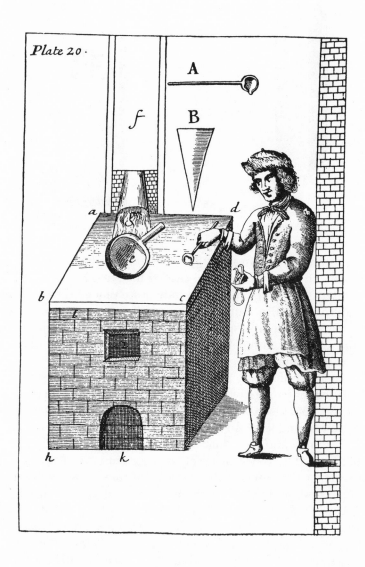

4. *Seventeenth-century typecasting as shown in "Mechanick Exercises" by Joseph Moxon (1683)*

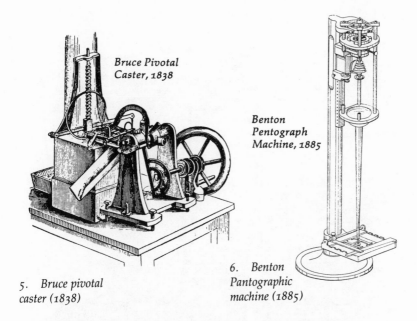

Bruce Pivotal
Caster, 1838

Benton
Pentograph
Machine, 1885

5. Bruce pivotal
caster (1838)

6. Benton
Pantographic
machine (1885)

typefounder, invented a pantographic device which could en-
grave either a punch or a matrix (figure 6). While Benton was in-
terested only in casting single types, his invention became an ab-
solute necessity in the evolution of the typesetting machine
which could not have been successful without a precise method
of manufacturing punches rapidly in order to produce a sufficient
volume of matrices. He thus improved the production of the type-
founder at the expense of promoting his own competition.

Mechanization of Typesetting (1850–1950)

Type was set principally by hand until the last decade of the nine-
teenth century. From 1850, however, there were numerous at-
tempts to automate typesetting, most of which resulted only in
machines for assembling founders' types in various ways. The
technique of actually casting type by keyboard operation was suc-
cessfully developed by Ottmar Mergenthaler in 1884 with his Lino-
type machine which cast an entire line of type in a single opera-
tion. (See figure 7.)

Mergenthaler's basic contribution to mechanical typesetting
owed its success to his departure from a principle employed by
all of the earlier automated devices: single types stacked in rows

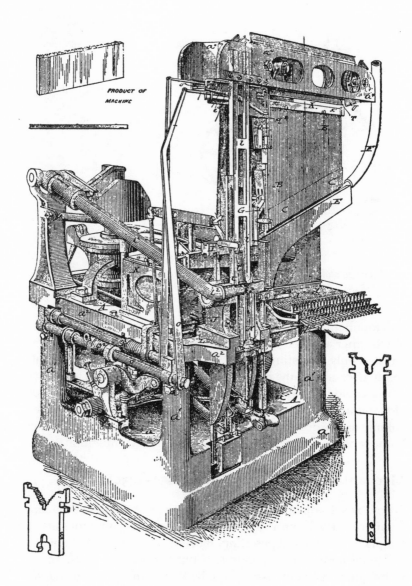

7. *Blower Linotype machine (1885) shown with early matrix and spaceband*

assembled in a keyboard operation, but which eventually were placed in the machine. Following numerous trials the Baltimore inventor decided that the use of brass matrices would be more economical since the "mats" could be automatically reassembled upon completion of the casting operation and would thus be available for continuous production.

The product of the Mergenthaler typesetter was a line of type cast as a single unit. This was quickly referred to as a "line o' type" by compositors, most of whom had little faith in the ability of a machine to take over their craft. The name later became generic when similar devices were manufactured upon the termination of the original patents. The most widely used of these, the Intertype machine, was almost identical when it first appeared in 1913, but its product was called "linotype composition."

The operation of the linotype was relatively simple. Its principal components consisted of a keyboard, a container for matrices called a magazine, a mold to form a line, or slug, a pot containing a molten metal alloy, and a distributor bar by which the matrices could automatically be returned to the magazine upon completion of the casting operation.

Upon the pressing of a key a matrix would drop from the magazine by gravity to a moving belt which placed it in an assembling elevator set to a prescribed line length. Between each word the operator would press a bar which released a wedge-shaped sleeve called a space-band. When the line was approximately full, the elevator was raised and automatically sent along a delivery channel to a position facing a mold of a specific type size and line length. A mechanism now pressed against the bottom of the space-bands, pushing them upward to spread the line of matrices to its full length. This action triggered a plunger in the metal pot to force metal into the mold against the row of matrices. The mold-disc then spun to a position which permitted the ejection of the slug to a slanted tray, called a galley. Meanwhile the line was passed to the distribution phase in which the space-bands were removed and the matrices sent to a distributor bar at the top of the machine which, in accordance with a code at the bottom of each matrix dropped the mats into their proper channels in the magazine. This sequence was continuous. Depending upon the skill of the operator, the size of the type, and the length of the line, as many as six lines per minute could be cast.

This necessarily brief discussion does not include the many im-

provements added to the slug-casting machine over the seventy years of its development, at the end of which certain models were capable of producing sixteen newspaper lines per minute via an automated keyboard. During this long period these machines, particularly in the United States, accounted for the major proportion of mechanical typesetting.

In 1887 Tolbert Lanston perfected a typesetting machine called the Monotype which cast single types actuated by a paper ribbon perforated upon a separate keyboard. By the turn of the century both Linotype and Monotype were well established, following a period of doubt during which the majority of compositors believed that they would be victimized by technological obsolescence. Typesetting was the last major component of printing production to be fully automated, following by many years of similar advancements in paper making and press manufacturing. The new typesetting techniques fostered tremendous expansion in productivity, by which newspapers and magazines profited by increasing both size and circulation. Despite the dire forecasts, the number of compositors actually increased, since neither of these machines were capable of making up pages, which required hand assemblage.

As the Linotype was most useful for composing textmatter it became evident that there was a need for a device capable of composing display type. This was filled in 1911 by the Ludlow Typograph, a machine by which slugs were cast from hand-composed matrices. When the basic Linotype patents expired a group of newspaper publishers formed a corporation which began the manufacture of the Intertype machine, almost identical to the Linotype. The ensuing competition assured continuing improvement in the slugcasting machine for the next forty-five years. It may be observed that the Ludlow Typograph was most widely used in newspaper offices and in the plants of magazine printers, in both of which required a great deal of display composition for advertising and for headlines.

The composing room then settled down to a long period of consolidation. Original models underwent numerous refinements, but no major new concepts were introduced to speed up typesetting until the post–World War II period.

Type manufacturing for typefoundries and composing machines underwent few basic changes from the pre-machine era, other than providing a greater market for skilled type designers.

Each manufacturer had his own procedure for producing a matrix, differing from competitors primarily in small details. As the sale of matrices was an important part of the business of building and marketing typesetting machines, the steel punch received a new lease on life. Following the development of Benton's pantograph engraving machine, the typefounders discarded the punch in favor of engraving a matrix for each letter, from which they could cast type for sale. But the punching of the countless matrices by the typesetting machine firms required many more punches than had been used by the foundries. The only difference in the manufacturing process was that the punches were engraved by the Benton machine rather than by hand.

When the use of typesetting machines had become fully established, the typefounders began to place greater emphasis upon the development of display typefaces. While a number of notable book types have been produced by foundries over the past half century, this has been a field in which the composing machine manufacturers have dominated, since keyboard operated typesetters are most economically employed in text-matter composition.

Up to 1950, machine-set type and hand-set type were completely compatible in an industry which enjoyed steady growth. There was naturally some overlapping of type designs from foundry to machine and vice versa, and even occasionally from machine to machine, but the guidelines were reasonable and in most cases respected. After 1950, however, the industry became involved in technological ferment primarily instigated by a host of firms attracted to the rapidly emerging field of electronic typesetting and hoping to replace the relatively small number of manufacturers of traditional typesetting equipment who had been the primary suppliers of graphic arts equipment for many years.

Single Types—Foundry and Monotype

Despite the overwhelming success of automated typesetting, from manual to digitized operations, there remains in all parts of the world the capacity to continue the centuries-old techniques common to the assembling of single types. Presently it is still possible to purchase type for hand composition in the form of fonts from type foundries, or, more likely, from firms which market types produced on Monotype equipment. Typographic designers

8. Single type, with leading

must therefore remain familiar with the terminology of an era which has not yet reached obsolescence. (See figures 8 and 9.)

While much of the present activity in hand composition is accounted for by private press operators or small commercial establishments, such machines as Linotype, Intertype, and Ludlow are still used for numerous specialized operations. The term "foundry type" refers primarily to single types cast in fonts by typefounders who cast type from matrices developed for their own use and which remain in their possession. Traditionally foundry types are cast in a metal alloy which is harder and more durable than that used in Monotype casting machines, and thus may be expected to wear longer.

The basic physical difference between foundry type and standard Monotype is the latter's lack of the groove. An exception is the type cast by the Thompson Typecaster, a machine manufactured by the Monotype firm until 1967. Thompson-cast type retains the groove at the foot of the type but at the back of the letter rather than in the center, as in standard foundry type.

Display Sizes of Type

The use of wood type is now quite restricted, and over the past half century has survived primarily for specialty printing such as broadsides and posters, point-of-purchase display, etc. However, the types are now considered to be historic artifacts and for many years they have become highly desirable acquisitions for private collectors who lovingly attempt to duplicate the typography of the middle and later years of the last century, when American wood types reached a state of artistic perfection (figure 10). Perhaps an indication of the continuing interest in the form has been their transfer to the catalogs of the manufacturers of photoletter-

9. *Type in composing stick*

ing devices. (Such interest is not to be confused with the trend which began in the 1960s in which wood type was utilized in the construction of collages, a practice which inevitably removed thousands of irreplaceable fonts from cases throughout the land, sadly depleting what remained of a great heritage of American typography.)

As a further note, these pantograph-cut wood types were not cut to the dimensions of the American point system of measurement (72-point, 96-point, etc.) but were listed as "line" (representing pica), with 12-line, for example, being the equivalent of 144-point, the largest size generally available in metal type.

With the introduction of display phototypesetting, such restrictions of type size were eliminated. These devices can readily compose types in any size required. The further ability to distort width has also made such equipment quite popular for a variety of commercial work, although in the hands of an untrained operator the result may not always be pleasing typographically.

Photolettering Devices

When keyboard phototypesetters became popular, it was evident that they were most efficient in producing text composition, although they had the capability of enlargement from a standard alphabetic grid or disc. To supply the display composition, several simple handoperated devices were introduced. Most of these are capable of delivering type projected from photo master fonts to either paper or film in single-line strips. In some the projection is the same size as the alphabet, necessitating a second step in an

OLD
WOOD
TYPE
DISPLAY
5
SPECI
MENS

10. *Typical wood type specimens*

enlarging camera if the size has to be changed. The machines are operated in normal room light, and the developing process is relatively simple.

Such devices as Filmotype and Headliner were an immediate success and used in many composing rooms and art studios. At first, all standard and contemporary fonts became available on film and, if copies of currently popular types, were advertised by number rather than by name. Manufacturers also developed many original type styles, particularly scripts and free-lettering styles. Since development costs of new fonts were relatively low compared to those producing new foundry types, great variety in style was soon available with the hand-operated phototypesetters.

Demand continued for machines which could enlarge or reduce fonts from an original master. The first device that could accomplish this was introduced. Named the Photo Typositor (figure 11), it met with almost instant approval and is still widely used. It also provided such features as italicizing, backslanting, shading, and condensing.

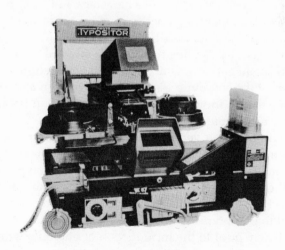

11. Photo Typositor

Phototypesetting

The Computer and Hot-Metal Typesetting

Along with a change to photographic composition, another new typesetting concept began to influence the industry—the harnessing of computers to either hot-metal or photographic typesetters. The fastest manually operated linecasting machines were capable of producing 6 newspaper lines per minute. In the 1950s, faster linecasters became available which were intended to be driven with paper tape punched on separate keyboards. They also utilized paper tape punched from the news service telecommunication lines. These machines, such as the Linotype Comet, could produce up to 12 newspaper lines per minute.

In order to cause the tape-operated typesetting machine to cast a line and begin a new one at the proper time, the keyboard operator had to know when the line was full. This was accomplished with "counting" keyboards which accumulated the width values of the characters as they were punched into the tape and signalled the operator when the end of the line was near. The operator then had to decide whether a complete word would fit on the line or else hyphenate a word at the proper point. In 1963 Compugraphic introduced the Linasec computer, which processed "idiot tape" containing continuous text with line endings only at the end of the paragraph. The Linasec contained, by means of a plug-in cartridge, the character widths for the font in use. Unjustified tape from a perforating keyboard was fed into the Linasec, which then punched a new tape containing the line-ending commands. The line breaks were inserted automatically as long as hyphenation was not necessary; if an entire word would not fit the computer displayed the word on a small screen for the operator to indicate the proper hyphenation point so that processing could continue.

By this time tape-driven linecasters, epitomized by the Linotype Elektron, could produce a maximum of 15–16 newspaper lines per minute. They had to compete with phototypesetters such as the Linofilm and Photon which were capable of twice this speed, and did little to slow the accelerating changeover from hot-metal to phototypesetting.

Immediately prior to the introduction of phototypesetting there was a flurry of interest in typewriter adaptations for typesetting.

Such devices as Varityper and Justowriter were adopted by a number of printers but they lacked the quality required for trade approval. The use of strike-on "typesetting" was tried again in the 1960s by IBM, with their Composer based on the popular Selectric typewriter. Although the quality was significantly better than the earlier machines, the limited number of character widths resulted in distorted characters and poor spacing which kept it from achieving wide usage.

Phototypesetting Systems

The idea of typesetting by means of photography was not at all new. Luther Ringwalt's *Encyclopedia of Printing*, published in 1871, included an account of a process called "phototypography." Prior to World War II, several typesetting machines were constructed employing photographic principles. But with the increasing dominance of offset lithography over letterpress printing, many regarded the setting of metal type solely for the purpose of pulling reproduction proofs for offset printing as inefficient and cumbersome. Following World War II, work began in earnest on ways to obtain a typographic image suitable for offset printing without using metal type.

Photography appeared to provide the obvious solution, and the "first generation" phototypesetters were designed to expose a character image from a film negative onto photographic paper. The negatives took many forms, but the problem of placing the character image in precisely the right position at high speed was a major hurdle.

Direct Entry Systems

The earliest phototypesetters, and for many years the most popular, were known as "direct entry" systems, combining the keyboard and photographic mechanism together in a single unit. The Intertype Fotosetter, introduced in 1950, looked and operated like a linecasting machine (figure 12); matrices (figure 13) dropped into position at the touch of a key, and the operator sent each line to be exposed after determining the proper ending point. It used a series of eight lenses to produce sizes from 4 to 36 point from a single size negative, the beginning of an unfortunate trend. A tape-driven model, the Fotomatic, was introduced in 1962. Its speed however still did not equal that of a tape-driven linecasting

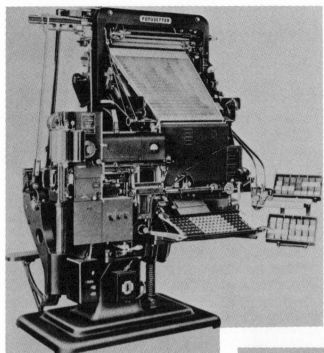

12. *Intertype Fotosetter, the first successful photosetting machine (1948)*

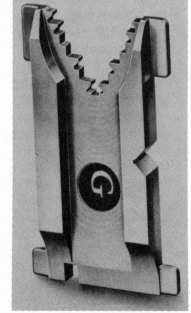

13. *Matrix for the Intertype Fotosetter*

machine. The advantages offered were the directness of the process and the sharpness of image.

The Monophoto, developed by the English Monotype Company, was another early phototypesetter patterned very closely on its hot-metal counterpart. The resemblance of such machines to the hot-metal devices which they were designed to supplant showed a dependence on tradition then believed necessary for complete industry acceptance, a subterfuge no longer required.

Direct entry phototypesetters continued to be manufactured into the 1970s by companies such as Compugraphic and AM Varityper, although these machines no longer resembled linecasters. Both companies also offered a variety of faster and more sophisticated phototypesetters. But for the small printer gingerly moving into phototypesetting the direct entry machines offered simplicity and economy.

The Era of Paper Tape

The introduction of the Mergenthaler Linofilm and the Photon 200 phototypesetters in the late 1950s marked the abandonment of the hot-metal machine as a model. The Photon, developed in France as the Lumitype, had an integral keyboard although a paper-tape interface was also provided. The Linofilm keyboard produced its own wide paper tape, which was then fed into the photographic unit. These machines, often classified as "second generation" phototypesetters, offered a significant increase in speed over the direct entry devices, but their major advantage lay in the ability to mix several different typefaces without a manual font change. This made them more suitable for advertising and display typesetting than their predecessors.

The Photon used an 8" disk containing 16 fonts of 90 characters each. The font disk spun constantly, and exposure was made by use of a strobe flash at precisely the instant when the needed character was in position. This concept of the constantly moving film master was used by many manufacturers until the advent of cathode ray tube (CRT) typesetters. In spite of the speed and precision of the light flash, it did lessen the sharpness of the image slightly, and had ramifications for type design as we will see later. The selection of fonts on a Photon disk was fixed when the disk was manufactured, which became a limitation if an additional font was needed which was not on the disk. This was later mitigated by the use of a pi font capability and a font disk with replaceable segments.

The Linofilm had 18 fonts of 88 characters available at one time, in the form of rectangular grids. Each font was separate, so the font mix could be changed by loading a different grid. Instead of moving the font grid, each of the 88 character positions had its own shutter which opened when that character was to be exposed.

The imposition of paper tape between the keyboard and photographic unit served primarily to allow the faster photographic section to operate at full speed and handle the production of two keyboard operators. It also had the advantage of storing the text and codes. Although the tape could not be corrected directly once it had been punched, correction lines could be retyped on a new tape which was then merged with the original to produce a third tape with the corrected lines in place.

It can be argued that phototypesetting achieved maturity and cemented its dominance over metal in the late 1960s with the introduction of faster, more affordable machines such as the Photon 713, the Mergenthaler V-I-P, and the Harris Intertype Fototronic. These machines incorporated computer capabilities which relieved the keyboard operator of the need to determine line breaks. This increased the keyboarding speed—albeit often at the expense of reasonable line ending decisions.

The V-I-P, introduced in 1970, attained speed ratings as high as 80 newspaper lines per minute from constantly-spinning film-negative fonts. It produced type from 6 to 36 point from a single film master, or up to 48 point using a master containing larger originals.

By this time the speed, versatility, and convenience of phototypesetting were well established. There were other advantages as well, although some can be considered a mixed blessing. The ability to overlap or superimpose characters allowed accents, as separate characters in the font, to be combined with any other character. This also provided a rudimentary kerning capability, allowing the italic *f*, for instance, to swing over or under the adjacent characters as needed. Also widely touted were the distortion functions allowing the character height and width to be changed independently to produce "expanded" or "condensed" type, or the vertical strokes to be inclined to the right to produce an "oblique" type as a pseudo italic (figure 14). The abuse of these functions contributed to the bad reputation of phototypesetting

	Optima	Fenice Bold
Roman	answ	**answ**
Obliqued	*answ*	***answ***
True italic	*answ*	***answ***

14. *Weight and character distortion in obliqued type*

among many typographers. Much was also made of the sharpness of the letter images. But in fact the photographic process tended to round off sharp corners, causing some designers to produce typefaces with exaggerated exterior corners and notches in the interior corners to compensate for this problem. Other persistent problems included the need to manually cut in correction lines on the photographic output (often referred to as a reproduction proof, or repro) and fluctuations in density resulting from variations in exposure or processing chemicals.

The ease with which film fonts could be produced resulted in an orgy of typeface piracy. While the established manufacturers such as Mergenthaler and Intertype had their own repertoire of typefaces to translate to the new medium, other companies were faced with a sudden need to offer a respectable range of fonts to their prospective customers. The result was a lot of typefaces with unfamiliar names which bore a remarkable resemblance to the most popular faces of the time.

The Typesetting Industry

Phototypesetting's growth had by this time resulted in the separation of typesetting as an industry from printing. The transportability of the phototypeset image compared to lead type reduced the need for typesetting to take place in the printing plant. Many new typesetting companies were formed to take make use of the technology, and some printers with a large investment in hot-metal equipment delayed the changeover or made a conscious decision not to take the step.

Lower set-up costs were certainly a factor in the establishment of new businesses. While phototypesetting equipment was not

inexpensive, it was significantly less than the cost of the number of hot-metal machines needed to offer the same capacity. The lower cost of fonts also contributed to the reduced startup cost, especially with the popularity of the "one size sets all" concept.

A hidden cost which was seldom considered was that of obsolescence. Linecasting machines were capable of running for fifty years with little more than routine maintenance, and the new models usually offered only evolutionary improvements. The rapid pace of development in the technology of computers and phototypesetting however meant that much equipment was considered obsolete within a few years of its installation. While obsolescence is irrelevant if the equipment is still producing satisfactory work, many companies felt compelled—or were compelled by competitive pressures—to upgrade one or more times to newer technology. The result has been not only business failures, but generally a lower profitability in the industry than had been anticipated.

Computerized Phototypesetting

Front End Systems

With the greater versatility of phototypesetters came the need for more command codes to be included in the text tape. The keyboard operators no longer had to make line-ending decisions, but much of the time they were working blind when putting the codes in the text. They could not see the effect of the codes, or know where a line was going to break, until the type was run out on the phototypesetter. And corrections either had to be set separately and cut into the original repro, or merged into a new punched paper tape which was used to rerun the entire output.

Thus was born the "front end system." In its simplest form it was a computer which processed the keyboard input to determine line endings, identified many coding errors, and sent the resulting text and codes to the phototypesetter. The transfer to the typesetting machine was sometimes by paper tape, but often took place over a cable connecting the computer and typesetter directly—referred to as being "on line" with the typesetter.

More important than the line-ending decisions (which many phototypesetting machines were capable of making themselves)

was the storage of the keyboarded text on a computer disk. This meant that the file was accessible for correction and updating at a video display terminal, and could then be reprocessed to produce corrected output. It also became possible to call the file up on the terminal after the line endings had been determined to check the results—and make changes if needed before sending the file to the typesetter. If something did not fit the way the operator expected, it was a simple matter to change the command for the type size, line length, or leading and process the file again.

Another very useful feature of front end systems, which had been present earlier in some phototypesetting machines, was the use of "stored formats." This allowed the operator to store a series of codes (and text if appropriate) which might be needed repeatedly—for instance, to set a subhead in a book. The codes to establish typeface, size, and position could be stored once and then recalled with a single command each time they were needed. Even more important was the ease of making changes. If individual codes were used in the file, then changing the point size or other parameter would require finding and changing each occurrence of the codes. With stored formats, only the format definition needed to be changed. The new codes would then be used by the computer each time the format call was encountered in the file.

Most front end systems store kerning tables for each font which define minute spacing adjustments to be made between certain pairs of characters such as Ta, r., and AW. These adjustments can also be stored in the typesetter. Compugraphic offers "sector kerning," in which the height of each character is divided into several horizontal bands. The minimum distance to an adjacent letter for each of these bands is stored with the character information in the font. The machine then evaluates these minimums for each character combination as the type is set, and uses the smallest allowable value for that combination.

The early front end systems did not show different type sizes on the screen, or position the text according to the codes (except for line endings). The screen showed the text with the codes in place, often using underlining, variations in brightness, or reverse video to indicate italic, boldface, or coding. But the codes used by many front ends were very mnemonic—such as [it] to change to italic, or [pt12] to set the type size to 12 point—which

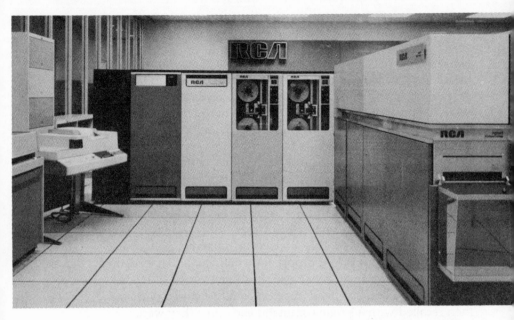

15. *RCA's Videocomp cathode ray tube (CRT) computer typesetter (1968)*

made them easier to remember and use than the actual typesetter codes for many machines. The computer then translated these to the typesetting commands when it processed the file.

Digital Typesetters

The next major step in phototypesetting took place with the introduction of "second generation" machines which produced their image from digital information rather than from an actual image. The digital description of the characters, stored on a computer disk, is used to display the letters on the face of a cathode ray tube (CRT). The characters are exposed onto the photographic paper or film either by direct contact with the face of the CRT, or by projection from the tube onto the photographic surface.

The Hell Digiset was the first typesetter to utilize fonts stored in digital form. It was introduced in 1967, and RCA offered an adaptation of it in the United States as the VideoComp (figure 15). Other CRT typesetters introduced about the same time were the Mergenthaler Linotron 1010 (for the U.S. Government Printing Office), the Linotron 505, and the Harris-Intertype Fototronic CRT. The Mergenthaler machines produced the CRT image by scanning characters physically stored in the typesetter. All of

these early CRT typesetters were expensive, high-speed units designed for large-volume output such as directories, database publishing, and newspapers.

Lower-priced digital typesetters introduced between 1975 and 1980 included the Harris-Intertype 7400, Mergenthaler Linotron 202, Alphatype CRS, and Compugraphic 8600. They typically offered size ranges from 4 point to 48 or 72 point, and line lengths from 45 to 108 picas. Output speed ratings were as high as 1000 newspaper lines per minute, although this varied substantially depending on the type size and the number of font changes required. The Alphatype CRS achieved a resolution of 5300 lines per inch by using a double sweep of the CRT screen, resulting in somewhat slower output. Fonts were stored on floppy disks or hard disks in the typesetter, and usually called into memory as required. While the disks could hold many fonts, not more than 2 or 3 could generally be in memory at one time. Therefore frequent font changes required loading and reloading the fonts from disk, which slowed down the output.

It is worth noting that the Alphatype and Harris-Intertype machines used up to five different font masters to produce their size range, while Compugraphic produced all sizes from one master. Mergenthaler took the middle road, offering many of their faces in two or three different master sizes. The different sizes were sold separately however, and in practice few typographers bought more than one master size for a font. The Linotype raster image typesetters use a single master font for all sizes.

The use of CRT typesetters and digital fonts produced a generation of faster, more reliable typesetters. Most of the new machines required little if any movement of lenses and font masters. Such mechanical functions in optical phototypesetters had been a source of reliability problems both in breakdowns and in maintaining the necessary precision of movement. Digital typesetters also usually offered a greater range of type sizes, and the ability to have more fonts on line at one time.

There was some loss of character sharpness through the use of CRT images as compared to those projected from a film master. However, the resolution of these typesetters was typically about 1000 lines per inch, and there was little visible deterioration in quality in smaller sizes. Use of the larger sizes offered by many of the machines often resulted in noticeable ragged edges and angles instead of curves.

16. *Major categories of phototypesetting systems*

The Laser Age

The big news of the 1980s has been the incorporation of graphics capabilities into video display terminals and typesetters. The use of terminals which could display both text and graphics in their proper position has made typesetting systems easier to use, by eliminating much of the memorization of codes. Placement of an illustration or a block of type can be done by moving the element to the desired position on the screen, and allowing the computer to give the necessary instructions to the typesetter. In fact, such terminals and microcomputers have become known as WYSIWYG (what you see is what you get) systems.

On the output side, laser typesetters have become the primary means of transferring the type-and-graphics image to film or paper. In many ways, laser typesetters are similar to CRT machines. They use digitally stored fonts, and create the image by turning a beam on and off at the proper moment as it moves across the surface of the paper. The most common CRT units build the characters with short vertical strokes the length of the type size, placing them one after the other as it moves across the page, while laser units usually scan the beam across the entire width of the paper, moving down slightly for each successive stroke. (See figure 16.)

Laser typesetters rely on a raster image processor to assemble the text and illustrations on a page before the actual image transfer takes place. The raster image processor takes the text and graphics data from the front end system and builds a "picture" of the entire page. This picture is broken down into millions of tiny dots, or "pixels," which are either on (part of the image) or off (part of the blank area of the page). The laser beam then moves across the page as many times as required to cover the entire area, turning on and off according to the raster page image. Since the beam is "painting" the whole area of the page, it is immaterial whether the image being formed is a character or part of an illustration.

Typesetters in this category are often denoted as "fourth generation" machines. Not all raster image typesetters use lasers, however. Others, such as the Itek IGX 7000, use a bank of LEDs (light emitting diodes) to expose the image. Others, including the Chelgraph IBX, form the image with a CRT. The unifying factor is the preparation of a page image in the memory of the typesetter which is then transferred to the photographic medium.

The primary disadvantage of raster systems at present is their low rate of speed compared to character-based CRT typesetters. Direct comparisons are difficult, but a page of type which might take thirty seconds on a CRT typesetter may take several minutes on a raster typesetter.

Microcomputers and Typesetting

The widespread use of microcomputers, or "personal computers," has made an impact on typesetting in many ways. Almost since the days of the first word processors, computer files have often served as input to typesetting systems, eliminating the need to rekeyboard the text. Typesetting front end systems have used more powerful minicomputer equipment, and it often required special hardware to transfer the files to the typesetting system and considerable conversion processing to create the necessary typesetting codes. Two trends seem to be at work to minimize the difficulties associated with such transfers.

The first trend is the availability of front end systems which operate on microcomputer equipment rather than minicomputers. Personal computers have increased in speed and power, large hard disks for file storage have become available, and the networking of microcomputers has been refined. They are now capable of performing the same typesetting tasks as minicomputer systems, sometimes at a higher level of performance. Microcomputers also offer modularity, making it easier to expand a system or break it down into smaller parts, and the reliability associated with commonly available equipment and parts. Magna Computer Systems for example offers a PC-based front end system patterned after earlier minicomputer systems.

The other trend, originating in the microcomputer area, is the extensive use of "desktop publishing" systems. As originally conceived, desktop publishing used a personal computer, a laser printer, and page makeup software to create a rudimentary typesetting system. Each of these components has its limitations. The computers do not have the specialized keyboards to allow easy control of typesetting functions. Laser printers, although similar in concept to laser typesetters, cannot produce the sharp, consistent image of a typesetter. The typical laser printer resolution is 300 dots per inch (horizontally and vertically, or 90,000 dots per square inch), while phototypesetters have resolutions from 1000 dots per inch to over 2500 dots per inch. (See figure 17.). In addi-

Laser printer output	Typeset output

Palatino
Helvetica

Small type is generally somewhat distorted on the laser printer.

Palatino
Helvetica

Small type is generally somewhat distorted on the laser printer.

17. *Laser printer output vs. typeset output*

tion laser printers print on plain paper, and the relative coarseness of the paper and the toner which bonds to it to create the image make higher resolution very difficult. There is a limit to the fineness of line which can be produced. As a result, laser printers tend to show less differentiation between light and bold faces than typesetters.

Laser typesetters can provide a method of obtaining high-resolution output from personal computer software. Through the use of "page description" languages such as Adobe PostScript and Hewlett-Packard's LaserJet Page Command Language the same computer instructions that produce a page on the laser printer can produce the same page on many laser typesetters at the higher resolution. The page makeup programs for desktop publishing are relatively unsophisticated in terms of typographic refinement and control, and not suited to high-volume page makeup. But it seems likely that the PC-based front end systems and page makeup systems will coalesce into related multi-level systems which can provide both ease of use for the non-professional and efficiency and tighter control at the typesetting end.

Digital Type Fonts

The conversion of a typeface from artwork to digital form and back to an image on the typesetter is a complex process. Fonts for CRT typesetters are almost always digitized by the manufacturer for a specific typesetter, and are available only from the manufacturer. With the increasing use of raster imaging devices, font sources are less restricted.

The common CRT typesetters build their characters with verti-

cal scan lines, and the maximum character size is limited by the maximum length of the scan lines. The digitized font contains the starting and ending points of these scan lines, thereby defining the shape of the character. The number of scan lines per inch remains constant; therefore as the type size increases the number of scan lines in the character is greater. This means that the typesetter must interpolate additional values for the scan lines which fall between those specified in the digital font. Conversely, when the type size being set is smaller then the master size of the digital font, there will be fewer scan lines.

Laser typesetters and printers utilize a raster image processor to build an image of an entire page before it is set. The page image is made up of millions of tiny dots, or pixels. To place a character in position on the page, the pixels corresponding to those in the character are set to print. The digital font contains the pixels which are to be printed for a particular size of type; a different size of type requires a different pixel definition. To avoid having to store the pixel image (or bitmap) fonts for each different size in the computer, most systems use outline or vector fonts as a source from which to create the bitmap fonts as needed.

Digital fonts stored in outline form contain a series of points which define the edges of the strokes of the characters. They have the advantage of taking much less storage space on the computer disk, and they are not size specific, But to use the outline fonts, the typesetter (or the computer driving it) must have the capability of converting them to bitmap form in the proper size as needed. This can slow down the output of the typesetter, if the number of fonts and sizes needed exceeds its memory capacity. As a new font or size is called for, it is constructed from the outline font, replacing a font already in memory; if the original font is then called for, it must be constructed again from the outline font.

Resolution

One of the major factors in the quality of digital typesetting is the resolution of the output—that is, the number of scan lines or dots per inch. At the low resolutions, such as the 300 dpi (dots per inch) common in laser printers, it is often possible to discern the raggedness of the edge caused by individual pixels trying to approximate a curved line for instance. At typesetting resolutions of 1000 dpi and higher, it is virtually impossible to see the stair-

18. *Irregularities resulting from CRT scan lines (400% of original)*

stepping effect of individual pixels or scan lines with the naked eye.

There are other problems associated with resolution however, aside from the simple visibility of individual pixels or lines. At 300 dpi resolution, the thinnest line that can be formed is slightly over three thousandths of an inch. Yet it is not uncommon for small sizes of many typefaces to have thin strokes which would be less than that thickness; they cannot be accurately reproduced at that resolution. (See figure 18.)

Even at higher resolutions, thin lines are difficult to reproduce well because each pixel must be on or off; it is not possible to have only part of the pixel turned on. Thus all strokes must be multiples of the pixel in thickness. At 1000 dpi, where each pixel is approximately one thousandth of an inch, a stroke which should be .0035 inches in thickness is forced to be either .003 or .004 inches, a difference of 15% from the ideal thickness.

Problems with stroke formation also occur with shallow curves, or strokes that taper quite gradually or are not quite horizontal or vertical. The slight flare at the ends of stems in Optima, for instance, is difficult to form with pixels. In the worst case, a stroke which is 5 pixels in width and swells to 7 pixels may change suddenly from 5 to 7 pixels if the tapering is symmetrical, adding a pixel on each side. If it is not symmetrical, then the stroke would change in two stages from 5 to 6 and then from 6 to 7. This sort of sudden change can be noticeable even at typesetting resolutions, and is even more apparent on thin lines.

Some of these defects can be reduced by judicious editing of the character image if the original font is produced in bitmap form. With fonts created in outline form (as most are) the bitmap image is determined by the computer or typesetter from the outline data. It is impossible to optimize the outline font to produce

the ideal pixel image at all possible resolutions on a wide variety
of typesetters.

A Font for All Sizes

Depending on one's point of view, the ability to produce many
sizes of type from a single font has been either one of the most
important features of phototypesetting systems, or one of their
most serious shortcomings. It has unquestionably reduced the
cost of installing a typesetting system and adding fonts to it, and
in turn no doubt resulted in an increase in the number of new
typefaces. By reducing the amount of computer disk storage for a
typeface, the use of single-size masters has made it possible to
have more typefaces available on the typesetting machine at one
time.

The problem is that large and small sizes of a typeface pro-
duced from a single master will show defects in proportion and
spacing. (See figure 19). As the type size decreases the propor-
tions should change to a larger x-height and slightly wider char-
acters. This helps to make the smaller sizes more legible, and
keeps the small counters in the characters such as "a" and "e"
from filling in during platemaking and printing. Small sizes also
need to have hairline strokes proportionally thicker to keep them
from breaking up or disappearing in the printing process.

When a font is set at a much larger size than the master, the
characters begin to look clumsy because the fine lines and serifs
are heavier than they should be. The space between letters is en-
larged along with the characters, although this can be compen-
sated for by most front-end systems. Enlarged characters are also
smaller than their designated point size, because the minimal
space above ascenders and below descenders required in text
sizes can become several points of shrinkage in large sizes.

Many manufacturers offer fonts in more than one master size
to provide better proportioning and fit in the typeset product, al-
though Alphatype is the only one whose fonts automatically in-
clude multiple sizes of masters. When the alternate masters are
offered as an option, many typesetting firms elect not to purchase
the additional masters, or don't go to the trouble of using them.
The solution to this problem may lie in the future, with software
and typesetters capable of making at least some of these adjust-
ments for any size selected.

Master Size	8 point	Type size 12 point	18 point
8 point	abcfgknqrsw	abcfgknqrsw	abfgkrsw
12 point	abcfgknqrsw	abcfgknqrsw	abfgkrsw
18 point	abcfgknqrsw	abcfgknqrsw	abfgkrsw

19. Comparison of type from 8, 12, and 18 point masters

Type Design Today

It seems that the relative ease and low cost of producing type-
faces for digital systems, and the popularity of laser printers,
have resulted in an increase in the number of new type designs
over the last few years. Yet most of the typefaces available for
phototypesetting systems are copies or adaptations of "old" faces
originally produced in handset type or for linecasting or Mono-
type equipment. This is understandable; the fact that these type-
faces have been used for decades or centuries speaks well for
their usefulness and acceptability.

Not that the many versions of Baskerville or Times Roman or
Palatino are interchangeable. There are good, bad, and indiffer-
ent versions of most classic faces—sometimes from the same
manufacturer. Compugraphic for example offers more than one
version of several typefaces, and is undertaking a program of re-
drawing many of their faces to take advantage of the new tech-
nology. In spite of technological advances, some traditional type-
faces do not translate well from metal type to phototypesetting.
Janson for instance, with its very thin hairlines and irregularities
from the handcut originals, seems to defy successful conversion
without a loss of personality.

Converting a hot metal typeface to digital form is not simply a
matter of scanning the original into a computer and storing the
image on a disk. If it is done properly (and often it is not), there
will be some redrawing of characters and fitting adjustments be-
tween characters. Most digital typesetters still use a unit system,
and even when the number of units to the em is as large as 54 or
144, the characters (including the space on each side) must be ad-

justed to fit the unit system. Type designs originally created for the Monotype were based on 18 units to the em, and the finer adjustments available in digital type offer opportunities for refinement of characters and spacing. Designs which were not originally unit-based, such as foundry type or linecasting faces, may require more adjustments. And of course the linecasting italic faces, which had to have characters the same width as the roman so both letters could be placed on the same matrix, can be dramatically improved by judicious reworking. Last but not least, a conscientious type design department will work to minimize the problems discussed earlier in connection with making pixels look like lines and curves, and producing many sizes of output from one master font size.

Typefaces for Phototypesetting

Several type designers who began their careers with designs for metal faces have continued to produce typefaces for phototypesetting and digital typesetting systems. Certainly Hermann Zapf and Adrian Frutiger come to mind in this regard.

Hermann Zapf, whose Palatino and Optima typefaces (originally designed for metal type) are expected by typographers to be available on every typesetting system, probably has the distinction of having suffered more unauthorized versions of his faces than any other living designer. He has been an outspoken advocate of typeface design protection, but has also stressed the need for type designers to understand and work with the new technology. His own design work for phototypesetting began in the early 1960s with the adaptation of his metal faces for the Linofilm, as well as new script faces such as Venture and Medici. In the 1970s several new Zapf faces were released for phototypesetting including Orion, Zapf Book, Zapf International, and Zapf Chancery. His work since then has been primarily for the European market. His versatility makes it difficult to categorize his typefaces, although much of his work has been based on a slightly squarish form known as the superellipse. Orion and Zapf Book for example, continuing a trend begun with Melior, are modern in stress and weighting, with a relatively large x-height. But like all of Zapf's designs they are formed with a master's calligraphic touch.

Adrian Frutiger's designs for phototypesetting began with the

Photon (Lumitype) machine in the 1950s, such as Egyptienne, Méridien, and Univers. More recent typefaces include Iridium, Glypha, Frutiger, Icone, Breughel, and Versailles. Although ranging from sans serif (Frutiger) and square serif (Glypha) to transitional (Iridium), his faces generally share a roundness and generous x-height. For Iridium Frutiger has used a slight shaping of the stems and serifs to give basic transitional letter forms a distinctive look without being distracting.

Although trained as a punchcutter at the Enschedé type foundry, Matthew Carter began his design career in phototypesetting, and now works exclusively with the production of digital typefaces through Bitstream, Inc. He designed several scripts and other faces for Linotype phototypesetters including Snell Roundhand, Cascade, and Auriga. By far his best-known typeface is Galliard, introduced in 1978. It is based on Granjon types from the sixteenth century, but attains a strength of character all its own through increased contrast of stroke weight and strong, sharp serifs.

The International Typeface Corporation has been a major force in encouraging and promoting new typeface designs and in reducing unauthorized copying of typefaces. ITC provides typeface manufacturers with artwork for the faces it licenses, and ensures payment of royalties to the designers. It has been responsible for the introduction of many new designs, including Avant Garde Gothic, Zapf Book and International, Benguiat, Isbell, Veljovic, and Leawood. In addition, ITC has undertaken the revival of some older faces such as Souvenir, Kabel, Clearface, and Cushing. ITC Garamond is not actually a revival, but ITC has redesigned the widely used classical face to fit their model of large x-height and a wide range of weights.

Designing for the Laser Printer

With the expansion of the market for digital typefaces to include laser printers, the low resolution of these machines has become a factor in typeface design. Lucida, designed by Charles Bigelow and Kris Holmes, is one of the few faces designed specifically for low-resolution output. There are no really thin lines, contrast between thick and thin strokes is slight, and the serifs are relatively heavy. The companion boldface is quite heavy, in order to provide sufficient contrast with the roman on laser printers. A second ver-

sion of the face, with more contrast between thick and thin strokes and a bit lighter overall, was later produced for high-resolution phototypesetting.

Other recent designs have attempted to accommodate the requirements of low-resolution output without sacrificing subtlety and refinement at higher resolutions. In designing Bitstream Charter, Matthew Carter has avoided fine hairlines and sharp serifs. The face is a transitional form with a moderate x-height. There is a bold weight and also a black to meet the need for a bolder face on laser printers. Amerigo, another Bitstream typeface designed by Gerard Unger, forgoes true serifs in favor of flaring at the ends of the stems similar to Optima or Albertus. The flaring is more pronounced than Optima, undoubtedly to reduce the visibility of stepping in low resolution. A third face, Carmina, was designed by Gudrun Zapf von Hesse and shows the influence of the broadedged pen. It has wedge-shaped serifs and fairly strong contrast. Perhaps because of the finer details it is not being promoted by Bitstream for use on laser printers.

Adobe Systems has also begun a program of original typefaces, beginning with Utopia by Robert Slimbach. It is clearly a transitional face with slightly thickened hairlines and modified serifs in the italic. Adobe has also issued its own version of the ubiquitous Garamond. Most notable is their decision to provide old style figures and true small caps in their fonts. They also provide swash characters for Garamond.

Design Trends

The influence of the radical changes in typesetting and type manufacturing technology on typeface design has been surprisingly slight. Readily visible trends are those of larger x-height, fewer hairlines, sturdy serifs, and multiple weights. The x-height, serifs, and lack of hairlines can be attributed to low resolution output devices and the problems of setting small type from larger digital masters. As discussed above, hairlines and fine serifs can break up or disappear in very small sizes, and small counters may close up. The tendency to produce several weights of a typeface may be result from a genuine demand, or it may occur simply because it *can* be done. Additional weights are produced

ROTIS SEMISERIF 65
ABCDEFGHIJKLMNOPQRS
TUVWXYZabcdefghijklmno
pqrstuvwxyz$¢£%
(.,:;!?ᴸ‟‟*/#)1234567890&

ROTIS SEMISANS 55
ABCDEFGHIJKLMNOPQRSTU
VWXYZabcdefghijklmnopqrs
tuvwxyz$¢£%
(.,:;!?ᴸ‟‟*/#)1234567890&

ROTIS SERIF 55
ABCDEFGHIJKLMNOPQRS
TUVWXYZabcdefghijklmn
opqrstuvwxyz$¢£%
(.,:;!?ᴸ‟‟*/#)1234567890&

ROTIS SEMISANS 65
ABCDEFGHIJKLMNOPQRSTU
VWXYZabcdefghijklmnopqr
stuvwxyz$¢£%
(.,:;!?ᴸ‟‟*/#)1234567890&

ROTIS SERIF 65
ABCDEFGHIJKLMNOPQRS
TUVWXYZabcdefghijklmn
opqrstuvwxyz$¢£%
(.,:;!?ᴸ‟‟*/#)1234567890&

ROTIS SEMISANS 75
ABCDEFGHIJKLMNOPQRST
UVWXYZabcdefghijklmnop
qrstuvwxyz$¢£%
(.,:;!?ᴸ‟‟*/#)1234567890&

20. Rotis Families from Compugraphic

with relative ease using computers, and the cost of producing digital fonts is not great.

Several recent typeface families have included related serif and sans serif designs. Lucida, referred to above, is available in both versions. Stone, designed by Sumner Stone and issued by Adobe Systems, also includes an "informal" which has serifs but is seen by the designer as being appropriate to correspondence and other functions where a typewriter might otherwise be used. The three families (serif, sans serif, and informal) have the same x-height and stem weights, and many similarities of letter forms. They can be mixed for emphasis and differentiation, or used independently. Other examples of this genre are Rotis, from Compugraphic (figure 20), and Gerard Unger's Demos, Praxis, and Flora, designed for the Hell Digiset typesetter in Germany. Rotis includes a Semisans which is actually a fairly high contrast gothic. The Serif design has a traditional serif structure and is generally transitional style although slightly condensed with rather squarish capitals. There is also a Semiserif which omits baseline serifs and has letterforms more akin to the Semisans.

Computers in Type Design

Computers have been put to use as a tool in the design of type-faces as well as in typesetting. The earliest and probably most common system is known as Ikarus, developed by Peter Karow of Hamburg, Germany in 1972. Its primary use is the modification of typefaces from existing artwork to produce additional weights or adjust fitting for a different unit system. The artwork is scanned or traced with a stylus connected to the computer, and can then be called up on the screen for inspection and modification. Ikarus can also be used to maintain uniformity of similar shapes throughout an alphabet—which may or may not always be desirable. With careful evaluation of the results and human editing when needed, such systems can greatly reduce the tedium of drawing and redrawing type designs. Sumner Stone, for example, estimates that he drew on paper only about 100 of the 4000 drawings needed for the Stone series. The rest were generated with the use of the computer.

A much different approach to computer-aided type design was taken by Donald Knuth, creator of Metafont. Metafont is a programming language which allows the operator to specify a wide range of parameters and characteristics of a character, which it then creates. However, it is not graphically interactive; the operator does not see the character (except in his mind) until after the program is processed. Modifications can then be made, but the process is largely trial and error.

Typeface design by computer has also reached the amateur, with the release of personal computer programs for the creation and modification of laser printer fonts. Some of the results may be too awful to contemplate, but the availability of such programs may develop an otherwise undiscovered talent. As laser printers increase in popularity, interest in typefaces and type design will also be more widespread with a corollary need for an understanding of the historical basis of typeface design.

Protection of Type Design

Unauthorized copying of type designs has had a long history. As early as 1503 the Venetian printer Aldus Manutius announced that he was fed up with the pirating of his books. While primarily concerned with the books themselves, he also mentioned that

copies of pirated type "did not please the eye, but have French peculiarities and deformed capitals." Modern type designers thoroughly agree with the Aldine protestation.

Here in the United States the copying of typefaces began in earnest when T. W. Starr devised the procedure by which existing types could be molded in wax and then manufactured via electrotyping process matrices. Any typefounder could simply copy those of his competitor's types which had proved popular with printers. The problem was somewhat alleviated when a trust called American Type Founders Company was formed in 1892 to buy up the majority of the foundries in the country. However a further encroachment occurred when automated typesetting became established around the same time. New difficulties arose since the printers who purchased these machines wished to acquire with them the types with which they had been long familiar.

During the 1920s, when several European typefoundries began to exploit the American market, the practice of copying once again became endemic on both sides of the Atlantic. At one point a German foundry brought American Type Founders into a German court for litigation over the copying of one of their types; it lost the case when ATF convinced the judge that its designer had simply used the same historic original which the German designer had sought out.

Not until the 1950s, however, did pirating become a more serious concern to the world's type designers. The introduction of a number of new typesetting machines brought to the marketplace manufacturers who were unfamiliar with printing types but who quickly realized that they must provide types of proven value if they expected to sell equipment. They argued, however, that this practice was not copying but "adapting."

The fundamental difficulty in protecting the type designers lay in the fact that to patent offices generally all printing types looked alike unless they were so unique as to be recognizable by untrained observers. Furthermore in the opinion of patent office administrators, such "observers" were considered to be "average," meaning of course that most readers could come into this category. The law profession also took this stance when urged to represent plaintiffs.

The inability to protect their intellectual property frustrated many type designers, most of whom depended upon royalties

based upon sales. No matter how well the adaptations of their types were accepted by printers as being authentic reproductions, they were denied compensation from the entrepreneurs who copied them.

That such chaotic conditions required an international solution became evident when a Congress of Industrial Property was convened in Vienna in 1973; here representatives of eleven countries signed an agreement for the protection of typefaces, but the United States was not among the signatories. In 1974 a conference was called in Washington by the United States Register of Copyrights, at which many opinions were aired, but at the close of the conference charges were made that attendance had been unfairly allocated and that the economic interest of manufacturers had dominated the findings, with the designers' difficulties taking second place. Efforts now made to work through the Congress were largely unsuccessful.

A partial solution for the type designers has been the formation of International Typeface Corporation, which for a number of years has commissioned type designers to prepare new styles which could then be offered to manufacturers of typesetting equipment. ITC prepares the designs for transformation to the various machines and the manufacturers pay a fee, part of which goes to the designer, whose types will then become available on the new machines. This concept frees manufacturers from maintaining staff to adapt the most popular types.

Undoubtedly, copyright protection will eventually be available for printing types in the United States despite such a long period of neglect. If so, it will be most welcome to future designers of printing types.

2
Nomenclature

Small Capitals

Most roman types, particularly those made for typesetting machines, are available in an auxiliary series called small capitals. These are cap letters, made to the size of the x-height of lowercase characters. In foundry type, small caps are purchased in separate fonts, but the number of available designs is limited. Almost all romans produced on typesetting machines have accompanying small cap alphabets in normal, or regular, weights. Small caps are generally not made for display types or for such styles as sans serif and square serif.

Lowercase abcdefghijklmnopqrstuvwxyz
Small Capitals ABCDEFGHIJKLMNOPQRSTUVWXYZ
Capitals ABCDEFGHIJKLMNOPQRSTUVWXYZ

Numerals

There are two commonly used styles of figures in roman fonts, oldstyle, and modern, or lining.

 Oldstyle figures contain x-height characters with ascenders and descenders as follows:

1,2,3,4,5,6,7,8,9,0

Lining figures align with caps and are all the same height:

1,2,3,4,5,6,7,8,9,0

In many type styles, either set of numerals may be obtainable, and this is generally so with the machine types. If a font is used primarily for straight-matter composition, oldstyle figures blend

ABCDEFGHIJKLMNOPQRSTUVWXYZ

abcdefghijklmnopqrstuvwxyz

ABCDEFGHIJKLMNOPQRSTUVWXYZ

0123456789 0123456789

, ; . : ? ! / - - — ' ' " " () [] ‹ › « » „ ¿ ¡ ff fi fl ffi ffl & $ ¢ £ % ‰ * † ‡ § ƒ ß

ÆŒÅØ æœåøÆŒÅØ ⅛ ¼ ⅜ ½ ⅝ ¾ ⅞ ⅓ ⅔

ABCDEFGHIJKLMNOPQRSTUVWXYZ

abcdefghijklmnopqrstuvwxyz 0123456789

*, ; . : ? ! / - - — ' ' " " () [] ‹ › « » „ ¿ ¡ ff fi fl ffi ffl & $ ¢ £ % ‰ * † ‡ § ƒ ß*

ÆŒÅØ æœåø ⅛ ¼ ⅜ ½ ⅝ ¾ ⅞ ⅓ ⅔

21. Complete font of Times Roman

best with text, but in tabular matter modern figures are needed. Careful printers purchase both sets and use whichever is better for the work at hand.

Font

While easier to describe a font of type as a collection of 26 caps and 26 lowercase characters, plus punctuation marks, an astonishing variety of characters actually makes up a *complete* font of type as illustrated by figure 21. The asterisk and dagger, fractions, accented letters, and a variety of characters are required for specialized typesetting.

Such an array is not available for every style of type, and the designer is cautioned to consult the printer's specimen book before determining type for a job. For example, the typographer might consider Bulmer appropriate for a chemistry text, but he will soon learn that none of the specialized characters required for this work are available in that style of type.

It will be obvious, then, that a thorough knowledge of printing types and their use comes only by study and familiarization with the numerous complexities among the hundreds of styles avail-

able to typographers from the various suppliers presently marketing typesetting equipment.

One formidable barrier to the novice typographer's rapid understanding of type forms is the lack of a broadly accepted terminology. Since there is no recognized authority, each writer must attempt some rationalization in a new text on the subject. The literature of typography over the past fifty years indicates diverse approaches by most authorities. Further confusion results from international differences in terminology.

Probably the most outrageous example of outright confusion in terminology is the description of the weights of type. While typographers generally agree that type weight refers to the relative thickness of stroke of a letter, the difficulty lies in describing the so-called median weight, from which all variants could be determined.

When most types had only two degrees of weight—light and bold—this was a relatively simple matter, but with the growth of commercial printing there came a demand for many other weights by which the advertising designer could vary his message in patterns of light and dark. Standard roman types do not allow indiscriminate thickening of stroke without loss of original character, but monotone letters such as the sans serifs and the square serifs can vary weight readily without apparent change in the basic design. Real difficulties became evident in the 1920s with the success of geometric sans serif types. Some of these have up to eight or nine variants of weight (figure 22), and there is great inconsistency among manufacturers in applying reasonable terms to describe these differences, as may be noted in the examples shown figure 23.

Any attempt to compile a table of comparative weights of all sans serif types results in complications. As traditional sans serif types—called gothic in the United States—currently enjoy great popularity, adequate terminology becomes more difficult.

Similar problems arise in the rational description of type widths. No adequate description of normal type width exists, so further chaos results in trying to determine whether a type is extended, medium-extended, condensed, or extra-condensed.

This book will not attempt to resolve such difficulties; that can really be done only by the joint efforts of makers and users of printing types. The history of such cooperation, necessarily inter-

ABCDEFGHIJKLMNOPQRSTUVWXYZ&
abcdefghijklmnopqrstuvwxyz 1234567890
Light

ABCDEFGHIJKLMNOPQRSTUVWXYZ&
abcdefghijklmnopqrstuvwxyz 1234567890
Medium

ABCDEFGHIJKLMNOPQRSTUVWXYZ&
abcdefghijklmnopqrstuvwxyz 1234567890
Alternate Medium

**ABCDEFGHIJKLMNOPQRSTUVWXYZ&
abcdefghijklmnopqrstuvwxyz 1234567890**
Bold

**ABCDEFGHIJKLMNOPQRSTUVWXYZ&
abcdefghijklmnopqrstuvwxyz 1234567890**
Alternate Bold

**ABCDEFGHIJKLMNOPQRSTUVWXYZ&
abcdefghijklmnopqrstuvwxyz1234567890**
Heavy

**ABCDEFGHIJKLMNOPQRSTUVWXYZ&
abcdefghijklmnopqrstuvwxyz 1234567890**
Alternate Heavy

**ABCDEFGHIJKLMNOPQRSTUVWXYZ&
abcdefghijklmnopqrstuvwxyz 12345678**
Black

22. *Weight changes in a single type series (Tempo)*

Graphic Arts Exhibit
LIVES OF ODD MEN
Futura Demi-Bold (Bauer)

SLUG FORMS ARE 73
Easy to handle when it
pertains to imprinting
Tempo Alternate Heavy (Ludlow)

THE EARLY PRINTER IN
They instructed some lo
Spartan Heavy (ATF)

23. *Types of similar weight by varying designation*

national to be fully effective, is indeed spotty. The British Standards Institution attempted to standardize typographic nomenclature in 1958, but this only resulted in continuing an inadequate dialogue among typographers.

Experienced typographers take these inconsistencies in stride. An encyclopedic knowledge of type forms is most useful, but it is no substitute for the ability to use the forms in designing print which is easily read and understood—the classic function of the typographer for five centuries.

In the following glossary, the first section deals with terms descriptive of various components of a type, either the physical character itself or its appearance in print. It will be useful in learning recognition factors. The second part covers the more generalized terminology of typography. The third and final part contains terms relevant to computerized typesetting.

Terminology

Many of the terms listed in this glossary are illustrated in figures 24, 25, and 26.

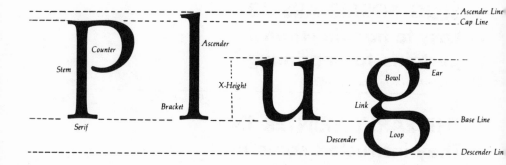

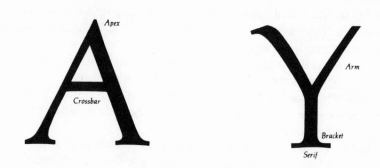

24. *Typeface terminology*

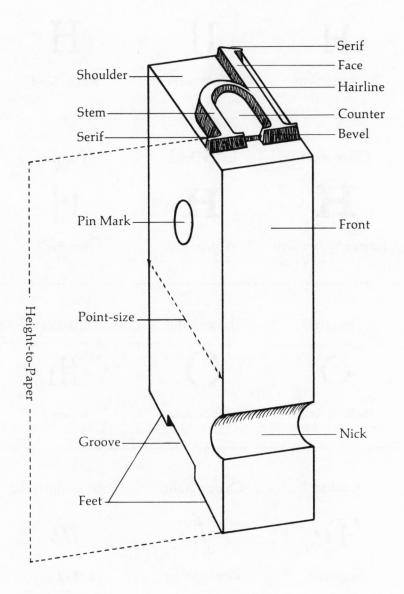

Serif

Face

Shoulder

Hairline

Stem

Counter

Serif

Bevel

Pin Mark

Front

Height-to-Paper

Point-size

Groove

Nick

Feet

25. *Typeface terminology*

Caslon	Bodoni	Stymie
H	H	H
Bracketed Serif	Unbracketed Serif	Square Serif

Clarendon	Latin Bold	Futura
H	**H**	H
Bracketed Square Serif	Wedge Serif	Sans Serif

Centaur	Baskerville	Caslon
Inclined Axis	Vertical Axis	Ligature

Caslon	Caslon Italic	Baskerville Italic
Te		*m*
Logotype	Kerned Letter	Hooked Serif

26. Examples of typographical terms

Arm Short horizontal strokes, as in E, F, L, T, or inclined upward as in Y, K.

Ascender The stem of a lowercase letter projecting above the x-height. Ascenders and descenders are sometimes called extruders.

Apex Juncture of stems, as in A, V, M, W, *etc.*

Axis Formed by the thinning of the stroke in round letters of Roman origin. In oldstyle types the axis is inclined to the left, while in transitional and modern types it is vertical. Exceptions occur due primarily to the vagaries of individual designers.

Back The top side of the physical type.

Base line The imaginary line supporting the bottom serifs of capitals and lowercase.

Bevel The space in the physical type between the face, or printing surface, of the letter and the shoulder. This is often referred to in the United States as the beard.

Body The size of the physical type as measured from back to front.

Bowl Rounded—fully or modified—forms in such letters as o,b,d, *etc.*

Bracket The joining of the stem of a letter to the serif. This is also referred to as a fillet. The term bracket is, however, readily understood in the sense of its meaning as a support.

Counter The partially or fully enclosed area of a letter.

Crossbar or cross-stroke A horizontal stroke connecting two stems as in A and H, or a simple stroke as in f and t.

Descender The stem of a lowercase letter projecting below the x-height.

Ear The stroke attached to the bowl of the lowercase g. Some typographers use the same term for the lowercase r.

Face The printing surface of the type.

Feet The solid area upon which the physical type stands. It is

formed by the groove which has been planed into the bottom of the type following the removal of the jet. European type which has been cast to the Didot size is sawed down to the Anglo-American height-to-paper, thereby eliminating the feet. Certain sizes of Monotype letters are cast without the groove, also eliminating the feet.

Fillet *see* Bracket.

Front The bottom side of the physical type.

Groove *see* Feet.

Kern A projection from the type body of a portion of the face of a letter, most frequently encountered in italic type. The need to protect the kern of the lowercase f has resulted in the holding over of the f-ligatures after most tied letters have been eliminated. In many styles of type the kern may remain within the limits of the body, but the term is still used to describe it.

Link The stroke connecting the bowl and the loop of the lowercase g.

Loop The lower portion of the g.

Nick The indentation in the front of the body, or shank, of the physical type. (In certain European types it is on the back of the letter.) The positioning of the nick aids in identifying type, but systematic placing of the nick to separate roman from italic, or lightface from boldface is rarely done today except in the lining gothics in which four face-sizes may be placed on a single body-size.

Shoulder The non-printing area on the physical type between the base-line and the front of the type. In certain styles capitals may be shorter than ascending lowercase letters, creating a shoulder between the face of the letter and the back of the type.

Serif The beginning or terminal stroke drawn at right angle or obliquely across the arm, stem, or tail of a letter.

Beaked serif The serif terminal of the arm of a letter, in the shape of a beak, occurring in such capitals as E, F, K, L, *etc.*

Bracketed serif *see* Bracket.

Hairline serif A light stroke, generally unbracketed, common to the modern class of types.

Hooked serif A serif common in italic lowercase type, in such letters as m, n, u.

Slab serif 1. The upper serif crossing the stem of a capital letter. This is a Venetian characteristic, appearing on M and W and occasionally across the apex of the A. 2. A monotone serif of equal weight as its stem, a feature of Egyptian or square serif types.

Spur serif A spur-shaped serif in certain types of Dutch origin (Janson) and on the crossbar of the lowercase f or t (Goudy Oldstyle, Erasmus Mediæval, *etc.*).

Wedge serif A wedge-shaped serif in such types as the Latin series (Latin Bold, Wide Latin, Chisel, *etc.*). Wedge serifs also appear in the Dutch-English Oldstyles on several lowercase letters, such as b, d, h, i, *etc.*

Stem All vertical strokes of a letter, and full-length oblique strokes as in V, W, and Y.

Flared stem A stem that thickens at either terminal, or both. They are used in such Roman types as Bernhard Modern and Egmont, and in such sans serif types as Optima, Stellar, and Pascal.

Tail Short downward strokes, as in K and R. The term is used for the Q, even when it is a curved, horizontal stroke.

Width The relative breadth of a character, referred to as "set" in Monotype composition. Standard variants from normal are condensed and extended (expanded), but further qualifications exist in certain commercial types.

X-height The height of lowercase letters without ascenders or descenders.

Glossary of Typographical Terms

Antique In the United States, a boldface, rather monotone letter with solid serifs, exemplified by Bookman. In Europe antique is

the term applied to roman type, in its secondary meaning as an Italian-derived letter, not as simply an upright letter.

Em The square of a type size. Only in the 12-point size does this equal 12 points. This term is not synonymous with pica.

En A unit equivalent in width to one half of the em.

Family All variants and sizes of one design, or style, of type (weight, width, roman, italic, boldface, *etc.*).

Font A selection of characters of one size and design of type.

Font scheme A method used by typefounders to determine the number of each character available in a single font of type.

Gothic Traditionally a term describing the lettering style of northern Europe during the period when Johann Gutenberg developed movable type, adapted as the first type. In the United States, since the 1830s, the term applied to sans serif types issued by European typefounders after 1820. The term is never used, however, to describe the geometric sans serif types such as Futura, circa 1926.

Grotesque The European term for sans serif styles American printers call gothic. In England the abbreviation, grot, is frequently used.

Height-to-paper The height of type from foot to face. Under the Anglo-American point system this measures .918 inch. In continental Europe there are several heights, but .928 inch is most common.

Italic A sloped or cursive variation of roman. In most cases this represents a complementary style of the upright letter, although some of the lowercase letters may change form slightly, and the serif structure is different. Modern usage requires an italic to accompany a roman in most types designed for continuous reading.

Ligature Two or more joining characters on a single type body. The term is still used to describe joined characters even when the types are produced in lines, as in linecasting and phototypesetting machines. Common ligatures are "f" combinations, originally designed to protect the kern of the "f" from contact with

an ascending character. A few other ligatures survive, such as st and ct.

Logotype Two or more characters on a single type body. The basic difference is that the letters are not joined. The linecasting machine firms have developed many standard logotypes such as Ta, Te, Va, Vo, to eliminate what might be an unsightly gap of space under the overhang of an arm. In advertising terminology, logotype is simply the name or trademark of a business firm.

Oblique A sloped roman in which the characters retain their roman shapes. The inclination is generally less than in a normal italic. The oblique characters are seen more frequently in the sans serif styles.

Pica A unit of measurement equaling 12 points, or 1/6 inch, in the Anglo-American point system. The Didot equivalent of a pica is called cicero.

Point A unit of measurement equaling .01383 inch, the basis of the Anglo-American point system. The Didot equivalent, called corps, measures .01483 inch.

Roman An upright letter, as opposed to a sloped, or italic, letter. The term also describes a style of type based upon Italian manuscript hands of the fifteenth century.

Series All sizes of one design, or style, of type.

Swash A decorative, flourished variant of a standard italic letter, more frequently seen in capitals than in lowercase.

Titling type A font of capitals, occupying most of the body of the type. It follows that a 24-point titling type is considerably larger in face than a corresponding 24-point, in which there is a lowercase alphabet.

Weight A letter's relative amount of blackness. Proper terminology for weight has never been precisely determined. In types used for continuous reading, two weights are generally used—the original design, called either regular or light, and a boldface. Square serif and sans serif types have as many as eight or nine different weights, differently described by each manufacturer. Most likely this imprecision can never be corrected.

Glossary of Computerized Typesetting Terms

Bitmap A digital representation of a character or page area with each dot in the print area represented by a bit in computer memory, set to on (print) or off (non-printing).

Cathode ray tube (CRT) In a computer terminal or phototypesetter, the surface on which an image is formed by stimulating the phosphor coating with a moving electron beam.

Command code An instruction embedded in a text file to cause the typesetting machine to set or change a parameter such as typeface, size, or line length.

Desktop publishing The activities of keyboarding and page makeup using a microcomputer and printing on a laser printer or similar device.

Direct entry A phototypesetter which outputs the text more or less immediately as it is keyboarded and does not store it in a permanent and editable form.

Dots per inch Linear measurement used to express the resolution of typesetters and laser printers.

Floppy disk A flexible disk with a magnetic coating used for the transfer of programs and data to and from a computer or typesetter.

Formats A series of command codes and/or text stored in a computer or typesetter which can be recalled with a single command, thus reducing repetitive keyboarding of command codes and assuring uniformity.

Front end system A computer used to prepare text for a typesetting machine; usually includes the capabilities of storing the text in editable form, hyphenation and justification, and often page makeup.

H & j Hyphenation and justification; the determination of line breaks and, if allowed or needed, hyphenation points within words.

Hairline The thinnest strokes of characters with strong weight contrast, such as a modern or Dutch-English oldstyle typeface.

Hard disk A computer data storage device consisting of two or more rigid disks with a magnetic coating, on a common spindle; usually permanently installed in the computer.

Hot-metal Typesetting machines consisting of a keyboard and a casting device producing either solid lines of type or individual characters in assembled form from molten metal.

Hyphenation and justification *See* h & j.

Idiot tape Perforated paper tape used to drive hot-metal or photographic typesetting machines, containing line-ending codes only at paragraphs.

Kerning (a) In metal type, the extension of part of a letter beyond its rectangular body to rest on the body of an adjacent character, such as an italic *f*. (b) In phototypesetting, automatic adjustment of spacing between pairs of characters according to a table of values for each font stored in the computer.

Laser printer A computer printer capable of low-resolution typographic and graphic reproduction; the image is transferred to a photosensitive drum by means of a laser beam and then to paper in the manner of a copying machine.

Laser typesetter A typesetting machine in which the image is transferred to photographic paper or film by a laser beam moving across the surface and turning off and on to expose the desired areas of the paper.

LED Light emitting diode; a tiny electronic light source. An array of LEDs can be used as an alternative to a laser beam to expose an image onto paper.

Microcomputer A "personal" computer small enough to fit on a desktop; capable of performing one task at a time.

Minicomputer A computer capable of supporting multiple terminals and often having the ability to process more than one task at a time.

Outline font A digital font in which the stored information defines points on the edges of each character.

Pagination The process of dividing running text into pages, including placement of footnotes, illustrations, and tables.

Pi font A font containing special-purpose characters which are not part of a standard font.

Pixel A dot in a raster image which can be turned on (printed) or off (not printed) to form the image.

Raster image processor A computer which assembles a pixel-by-pixel image of a page in memory using typographic and graphic data from a front end system, and then transmits it to the printer or typesetter.

Reproduction proof The final output from a phototypesetter, or a high-quality proof on coated paper from metal type, to be used as original copy in the making of printing plates; also known as repro.

Resolution The number of dots or scan lines per inch used by a laser device or CRT typesetter to form an image.

Sector kerning Automatic character-fit adjustment based on values stored with the font for several vertical positions on each character.

Stored formats *See* formats.

Unit The smallest increment of character width and spacing in a typesetting system, expressed as a fraction of the point size; in a 54-unit system, each unit equals 1/54 of the type size being set.

Video display terminal The terminal (monitor and keyboard) on which files from a front end system can be displayed for editing, or new files created.

Word processor A computer or software used for text input, editing, and formatting; files may be sent to a computer printer or transferred to a typesetting system.

WYSIWYG What You See Is What You Get; a terminal which shows a reasonably accurate visual representation of the printed output to be produced from a file.

3
Type Classification

The Need for a Systematic Approach

Beginning with the invention of movable type in the fifteenth century, printers adopted the lettering styles of the scribes as models for their types, attempting to produce exact duplicates of the manuscript texts of the period. In Germany types closely resembled the gothic manuscripts common to the area (figure 27). In Italy, where humanist roman letters were widely admired (figure 28), printers quickly learned that to sell their printed books they must suit the reading habits of their prospective customers.

As the craft of printing spread, however, the various previously localized manuscript styles became better known wherever books were read. Soon printers acquired more than one style of type in order to meet the demands for a wide variety of texts. During the sixteenth century, the art of typefounding, originally an integral part of the operation of every printing office, became a separate entity, since an increasing number of printing offices were too busy to cast their own types. Competition in the marketing of types now obliged the printer to broaden his typographic resources.

As long as printers were concerned primarily with the production of books, the variety of type styles was held to reasonable proportions. However, when the commercial or jobbing printer began to meet the demands of the Industrial Revolution for the broad distribution of manufactured products, this was no longer the case. During the nineteenth century typefounders enjoyed spectacular growth. Greater competition for the sale of type produced new designs in bewildering profusion. (See figure 29.)

While continuing this trend during the early decades of the

Confiteant dño mistdie eius :
lia eius filijs hominu, Ut facri
ficiu laudis : 7 annuntient opera ei
tatione, Qui descendut mare in
facietes optatione in aquis mul
viderut opa dñi : et mirabilia eiu
do, Dixit et stetit spirit9 prelle
ti sut fluctus eius Ascendut usq
et descendunt usq ad abissos : a
in malis tabescebat, Turbati l
sunt sicut ebrius : et omnis sapii
uozata est, Et clamauerut ad i
tribularent : et de necessitatibz e
eos, Et statuit prellam eius in
luerut fluctus eius, Et letati su

27. *Type of the Mainz Psalter* (1457)

Demū Atreus atqʒ agamemnō qui decimo atqʒ octauo ſui regni anno urbem troianam expugnauit.Quare omnibus diis ac eroibus græcorū multo uetuſtior Moyſes inuenitur:et oportet ſeniori a quo Iuniores hauſerunt multo magis credere.Non enim Homero ſolūmodo Moy⁄ ſes ſuperior:uerum etiam omnibus qui aliquid apud græcos ſcripſere. Quippe Cadmus a quo Irās græci habuerunt multo poſterior Moyſe iuenitur.Scripſerunt autē apud græcos ante Homerū Linus:Philam⁄ mon:Thamyris:Amphiō:Orpheus:Muſæus:Demodotus:Phemius: Sybilla:Epimenides cretenſis qui ſpartā petiit:Ariſtæus:Preconeſeus. Aſbolus:Centaurus:Iſatis:Orimō:Euculus:CyPrius:Orius: Samius: & Athenienſis pronetida.Linū igitur herculis magiſtrū fuiſſe conſtat: qui ante troianum bellum una fuit generatioē.Tlepolemus enī filius eius cum Agamemnone in ilium militauit.Orpheus autem æqualis Herculi fuit:quem Muſæus audiuit.Amphio duabus generationibus troianū bellum præceſſit.Demodocus uero:atqʒ Phenus alter ī Ithaca: alter apud pheacas troiani belli temporibus uiuebant.Thamyris etiā: & Philamon non ante ipſos fuerunt.Sed de Poetis ſatis dictum eſt. Nunc de his ſcribamus:qui apud græcos ſapientes habiti ſunt.Minos igitur:qui ſapientia & legum ſolertia cæteris omnibus excelluiſſe uide⁄ tur Lyncei temporibus:qui poſt danaum argis regnauit undecima ge⁄ neratione poſt Inachū fuit.Lycurgus autem cæntum annis āte primā olympiadem leges lacedæmoniis dedit.Dracon ī olympiad ⁻rigeſima ſexta leges atheniéſibus tulit.Pythagoras in ſexageſima & ſecunda flo⁄ ruit.Oſtendimus autem in ſuperioribus quadringentis & ſeptem ānis poſt Ilii euerſionē olympiadas incœpiſſe.Thales uetuſtiſſimus oīum: qui ſeptē ſapientes appellātur in quinquageſima uiuebat olympiade. Hæc tacianus:nunc Clementem audiamus.Apion inquit grammaticus uir hiſtoriarum peritiſſimus:qui pliſtonices nominatus fuit acerrimus iudæorum hoſtis adeo:ut etiam aduerſus eos uolumen ediderit nec in iuria:ægyptius enim erat.Ptolemæum Médeſium ſacerdotem:qui tria uolumina de rebus geſtis ægyptiorū edidit teſtem adducit:qʒ Amoſis: qui auarin ægyptiorum urbem euertit:& Inachus argiuorū rex eiſdem téporibus fuerunt.Quo quidem Amoſide regnante ab ægypto Moyſe duce iudæos profugiſſe cōfirmat.Res autem argolicas:quæ ab Inacho cœperunt Dionyſius Halicarnaſeus in libro de téporibus omniu græ⁄ carum rerū uetuſtiſſimas fuiſſe oſtendit.Ab Inacho autem ad troiana tempora uiginti generationes connumerantur:anni ad minus quadrī⁄ genti.Aſſyriorū autem regnū antiquius cæteris omnibus fuiſſe cōſtat: cuius quadrīgenteſimo atqʒ ſecūdo āno trigeſimo ſcilicet atqʒ ſecūdo

28. Pages from the Eusebius of Nicolas Jenson, Venice (1470)

UNSURPASSED NOVELTIES
AND MAGNIFICENT ASSEMBLAGE OF
HISTORICAL AND OLYMPIAN ENTERTAINMENTS!
AT THE
CIRCUS ROYAL,
At Mr. W. ALLEN's,
Yorkshire Stingo, New Road, Marylebone.

Licensed Pursuant to Act of Parliament, of the Twenty-fifth George the 2nd	And Under the Especial Patronage & Sanction of Her Majesty THE QUEEN

Mr. CORNWALL feels the utmost satisfaction in making known to the Public, that his MAGNIFICENT CIRCUS was honoured with a CROWDED ATTENDANCE, who expressed the most unbounded admiration of the Building, and loudly applauded the general representations. The Spectators, who observe for a moment the extensive and commodious accommodation provided for the Public—the COSTLY STYLE and correct taste of the EMBELLISHMENTS—will agree with Mr. C. in asserting, that the skill of the Architect, and the talent of the Artist, have been equally successful, and that this is the FINEST CIRCUS ever offered to the Public.

MONDAY, April 24th, and during the Week,
The Performance will commence with the
LEAPS OF WONDER,
By Mr. LAVATER LEE, in which he will take a surprising
LEAP OVER 14 HORSES!
☞ No Exhibition yet introduced has caused so great a sensation as these TERRIFIC FLIGHTS IN THE AIR.

Mr. CORNWALL'S New Act of Riding, Representing The
GLADIATOR HORSEMAN
In the attitudes of Attack and Defence, as practised by the Roman Combatants, he then changes to
Fame! with his Brazen Trumpet
In Rapid Flight, and depicts to the Audience the various Postures which Painters have assigned to this Imaginary Personage.

An interesting Double Act of Horsemanship, performed on Two Swift Steeds, by Mrs. CORNWALL and Mr. J. SAMWELL, entitled	Mr. LAVATER LEE will appear as
## LOVERS' QUARRELS	# SHAW
To be succeeded by the appearance of Messrs. HOREA, WILLIAMS, RICHA and HOLLAND, as The	### THE
## ENCHANTED ARABS	### Life-Guardsman!!
Displaying the whole of their surprising and powerful Gymnastic, Pyramidical Groupings, and Feats of Strength, forming at the termination of each Feat, a highly Classical and Beautiful Tableaux.	#### Who was Killed at the Battle of Waterloo.

To be followed with a magnificent Entreé of
MODERN CHINESE WARRIORS!
Who, in the course of their Evolutions, will perform a Novel Waltz and Gallopade, for which their Steeds have been tutored, to glide through the many Figures and Waltzing of that difficult dance; illustrating, by a series of Scientific movements, the management of the Horse and now the advancing, now receding evolutions, of a Troop of Chinese Cavalry. The undulating character of the figures goes through is rendered picturesque by the flaccid and waving of the banners with which each horseman is provided, and which he agitates in unison with the strains of music, and the regulated paces of the horses' galop. The Music by Mr. MOYE.

THE
CHIARINI FAMILY,
Will appear on the ELASTIC CORDE, and go through a variety of New Performances, in particular MDLLE CHIARINI will Dance the
CRACOVIENNE!

By particular desire, Mr. SAMWELL, will introduce
THE DIMINUTIVE STEED,
Who will go through the whole of his amusing training. This extraordinary little animal has created a universal degree of admiration The peculiar instinct displayed by him was formerly supposed to be confined exclusively to the canine race—it remained for the trainer and instructor of this diminutive creature to prove the fallacy of this opinion, and shew how the faculties of the Horse can be brought forth by judicious and skilful training.

After which a splendid double Riding Act invented by Mr. SAMWELL, and to be represented by him and his Infant Pupils, Masters ANGELO CHIARINI, and M. P. CHIARINA, a child only 5 years of age—entitled
SPRITE OF THE MORNING STAR,
And the Mischievous Nymphs.
The Situations, Ballets, and Equestrianism of this beautiful Scene will be aided by the whole Arcna, displaying every Decoration and Embellishment that can realize the description of The
GARDEN GROUNDS & FLORA AND POMONA

Mr. J. SAMWELL, one of the most Elegant and Graceful Riders of the day, who will portray the character of
A SPANISH DON
The beautiful and correct attitudes into which the performer throws himself during the unusual quick pace of his charger, will satisfy the most dubious that the art of Equestrianism may, by practice and perseverance, be brought to a state of refinement, bordering on the incredible. Mr. SAMWELL will in the course of his evolutions, perform the most astonishing feats, and conclude, by urging his steed to a fleetness beyond the power of imagination to describe, and yet retain his seating until the eyes of the spectators become dim from following the circuit of his swift career.

The Performance will conclude with an entirely new Comic Pastoral Ballet of Action or
TWO TIGHT ROPES,
With New Dresses, and a Selection of Popular Airs, entitled
LUBIN AND ANNETTE,
OR, THE WANDERING PEDLAR.
Farmer Acorn..........(a common good natured Old Man).........Mr. WILLIAMS,
Dame Acorn.......his Wife a crusty Old Woman........Mr. HOREAN, Lubin.....Mr. CHIARNI, Annette....Miss CHIARINI

PRICES OF ADMISSION.
Front Boxes, 2s. 6d. Second Price, 1s. 6d. Side Boxes, 1s. 6d. Second Price, 1s. 6d. Pit, 1s. (No Second Price, except for Children under 10.) Gallery, 6d. (No Second Price to the Gallery.) Children under 10, Second Price to the Boxes and Pit. Second Price to commence at 9 o'Clock.
Clowns, Messrs. ARTHUR NELSON, HOREAN. and BROWN.
Riding Master. Mr. LAVATER LEE.
Box-Keeper - - - Mr. HARRY.
Acting Manager and Conductor of the Circle, Mr. SAMWELL,
The Nobility and Gentry wishing for Seats in the Boxes, are respectfully apprised that it is necessary to secure them at the Box Office, which is open daily from Twelve till Four o'Clock.
N.B.—Mr. CORNWALL will not be answerable for any debts contracted in his name, without a written order signed by him.
☞ NO SMOKING ALLOWED IN THE CIRCUS.

29. Circus handbill (circa 1840)

present century, however, the foundries joined with the composing machine manufacturers in a return to the historic types, formerly the bread and butter types during the era of the book printer. While many of the nineteenth-century display types have been thankfully forgotten, the concept of producing a heterogeneous mixture of designs has survived. There are now several thousand different types in everyday use throughout the world. Many of them have remarkably similar characteristics, thus complicating the problems of typeface recognition.

It is not enough simply to recognize a type instantly, something which can be done by memorizing characteristics or by tracing alphabets. The purpose of knowing types is their effective use in the production of the printed word. If they are to be used with a sympathetic understanding of their structure, it is necessary to learn their evolution. Historic grouping not only serves to assemble types of like attributes but also provides a key to their rational use.

Some of the early printing manuals attempted to deal with an orderly presentation of printing types, but the classification systems were relatively simple, depending primarily upon such broad divisions as "roman" and "italic."

The scope of the graphic arts became more international after World War II, partially because of the great growth in the technology of typesetting under the constant demand for faster production. Every new development is quickly evaluated on an international scale. Often the technologists who develop new machines are relatively unfamiliar with printing methods. In the 1950s, with new types emerging weekly, European and American typographers became concerned with the difficulties encountered by young people following graphic arts careers. Little consistency existed in the procedures for studying printing types with the aim of obtaining a working knowledge of the countless varieties known.

Despite the demands of the new technology, however, the need exists for a rational method by which everyone concerned— students, bibliographers, compositors, printers, art directors, and engineers—can quickly work with the multiple styles of letterforms.

The problem was discussed in a number of seminars and conferences and appeared in the pages of trade periodicals; all sources sought to agree upon a logical method of classifying typefaces. The issue became more complicated when several methods

were recommended, each having its adherents and detractors. Although under discussion internationally for many years, no full agreement has ever been reached.

The Vox System

Maximilien Vox, a noted French typographer and teacher, has been one of the most active proponents of an international system. In 1954, he suggested a method which was endorsed by many European printers. The Vox system has nine divisions:

1. **Humanes** Roman types which stem from the humanist manuscript hand of the fifteenth century, as copied by Italian printers prior to 1500.

2. **Garaldes** French types developed during the sixteenth century, of which Garamond is an example. These letters are modifications of earlier Italian types.

3. **Réales** Eighteenth-century types, of which Baskerville is representative.

4. **Didones** Later eighteenth-century types, exemplified by Didot and Bodoni. These styles have the greatest stroke contrasts of the roman types and generally have unbracketed serifs.

5. **Incises** Types modeled after letters of the first and second centuries.

6. **Linéales** Basically, sans serif types.

7. **Mécanes** Types variously called square serif, Clarendon, Egyptian, slab serif, *etc.*

8. **Scriptes** Types based on cursive writing styles produced by the broad pen, the brush, or the engraver's burin.

9. **Manuaires** Twentieth-century types produced on the pantograph machine which do not consciously imitate the historic types.

The ATypI System

In 1961, a system which closely follows the plan of M. Vox was proposed by Association Typographique Internationale, repre-

sentatives of typefounders, composing machine manufacturers, typographers, and printers from Europe and the United States. The ATypI recommendation for type classification follows:

1. **Humane** The fifteenth-century romans generally associated with the Italian printing of the period.

2. **Garalde** French types of the sixteenth century.

3. **Réale** Transitional types (Baskerville, *etc.*).

4. **Didone** Types similar to those of Didot and Bodoni.

5. **Mécane** Square serif designs.

6. **Linéale** Types without serifs.

7. **Incise** Types with wedge-shaped serifs.

8. **Scripte** Cursive types based upon handwriting.

9. **Manuaire** Display types.

10. **Fractura** Blackletter types stemming from the northern European manuscript hand before the invention of movable type about 1440.

The Vox system was adopted by ATypI with very little change, indicating broad European approval of M. Vox's proposals.

The British Standard System

In 1965, the British Standards Institution, which had earlier attempted to rationalize typographical nomenclature—with particular reference to the widths and relative thicknesses of strokes in types—included type classification in its approach to standardization. The British Standards system follows:

1. **Graphic** Types which appear to have been drawn rather than written. *Examples:* Libra, Cartoon, Old English.

2. **Humanist** Typefaces in which the crossbar of the lowercase "e" is slanted; the axis of the curves inclines to the left; little contrast between thick and thin strokes. Derivation is from broadpen letters of the fifteenth century. *Examples:* Centaur, Kennerley.

3. **Garalde** Types with greater stroke contrast than in the Hu-

manist faces: the bar of lowercase "e" is horizontal; axis of curves inclined to left. *Examples:* Bembo, Garamond, Caslon.

4. **Transitional** Types in which the axis of curved letters is vertical, or inclined slightly to the left; serifs are bracketed. *Examples:* Fournier, Baskerville, Bell, Caledonia.

5. **Didone** Typefaces having an abrupt contrast between thick and thin strokes: the axis of curves is vertical; frequently unbracketed serifs. *Examples:* Bodoni, Corvinus, Scotch Roman.

6. **Lineale** Types with serifs. *Examples:* Univers, Optima.

7. **Slab-serif** Types with heavy, square-ended serifs, with or without brackets. *Examples:* Rockwell, Clarendon.

8. **Glyphic** Types which are chiseled rather than calligraphic in form. *Examples:* Latin, Albertus, Augustea.

9. **Script** Typefaces which imitate writing. *Examples:* Legend, Palace Script, Mistral.

The British Standards suggestions were circulated in 1966 in order to promulgate further discussion. There has been no subsequent publication of this system.

The DIN System

The most complete proposal for the classification of printer's types came from West Germany, where a committee recommended a method for the German industrial standardization group (DIN—Deutsche Industrie Norman). Since the committee was composed of authoritative typographers, such as the internationally respected Hermann Zapf and Dr. G. K. Schauer, Art Director of the Stempel Foundry in Frankfurt, its suggestions were received with interest. The DIN System, which is a good deal more inclusive than the other methods, is as follows:

1 **Romans**
1.1 Renaissance styles (Venetians). Only minor differences in stroke thickness, inclined axis for curved portions of characters.
1.11 Early types and styles (Jenson, lower case "e" with diagonal crossbar).

1.12 Late styles (Poliphilus, Garamond; horizontal crossbar in lower case "e").

1.13 Modern styles (Palatino, Weiss, Vendome; types designed after 1890).

1.2 Baroque Styles
Strong contrast in strokes, more angular serif formation, almost vertical axis for curved portions of characters.

1.21 Dutch styles (Van Dijk, Janson, Fleischmann).

1.22 English styles (Caslon, Baskerville).

1.23 French styles (Fournier).

1.24 Modern styles (Horizon, Diethelm, Times Roman).

1.3 Classical Styles
Horizontal initial strokes for lowercase characters, strong contrast in stroke thickness, right-angle serifs, vertical axis to curved portions of characters.

1.31 Early styles (Bodoni, Didot, Walbaum).

1.32 Late styles (Bulmer).

1.33 News styles (Excelsior, Candida, Melior).

1.34 Modern styles (Cornivus, Eden).

1.4 Free Romans
Romans with calligraphic modifications, *etc.*

1.41 Victorian styles (Auriol, Nicolas Cochin).

1.42 Non-serif romans (Steel, Lydian, Optima).

1.43 Individual styles (Hammer Uncial, Verona, Matura).

1.5 Linear Romans
Grotesques and sans serifs of optically uniform stroke thickness.

1.51 Early styles (Annonce Grotesque, Grotesque 9).

1.52 Modern styles (Futura, Spartan, Gill).

1.6 Block Styles
Egyptians and Antiques. Types with slab serifs.

1.61 Early styles (nineteenth-century styles).

1.62 Late styles (Clarendon).

1.63 Modern styles (Beton, Memphis, Rockwell, Stymie, Landi).

1.64 Typewriter faces.

1.7 Scripts

1.71 Stress variation (Legend).

1.72 Expanding strokes (Bernhard Cursive, Copperplate Bold, Invitation Script).

1.73 Uniform stroke (Signal, Monoline, Swing Bold).
1.74 Brush stroke (Mistral, Catalina).

2 **Black Letter**
2.1 Textura (Black Letter Gothic).
2.2 Rotunda (Wallau).
2.3 Schwabacher (Alt-Schwabacher, heavy-looking types).
2.4 Fraktur (Unger).
2.5 Kurrent (Chancery).

3 **Non-roman Characters**
3.1 Greek
3.2 Cyrillic
3.3 Hebrew
3.4 Arabic
3.5 Others

Italics, bolds, condensed versions, *etc.*, as well as decorated versions of the above listed basic styles are accommodated under the main type classification headings of the groups to which they basically belong.

A Rational System

The methodology of classifying types is obviously diverse. Perhaps it is too much to expect that a system will be developed that will satisfy all demands made on it. For example, the bibliographer's requirements for the recognition of typefaces differ considerably from those of the young graphic designer or the art director. Unfortunately, many researchers in type classification become so involved in procedure they forget the basic purpose of any attempt to formalize a structure—simple communication.

Many difficulties face the printer who attempts to classify typefaces logically. Terminology in printing is notably inexact; some of the efforts to clarify it seem to have exactly the opposite effect. An example is the attempt by the British Standards Institution to rationalize the various thicknesses of stroke in typefaces. The organization even bravely tried to clarify the equally redundant terms describing the widths of type. Neither undertaking has succeeded. For instance, nine widths are suggested from ultra-condensed to ultra-expanded, the median point being called medium; but there is no precisely understood standard for that particular width.

ABCDEFGHIJKLMNOPQRSTU
abcdefghijklmnopqrstuvwxyz
1234567890(.,:;!?" "-)*&$¢£%/

30. Lydian

When applied to type classification, this indefinite nomenclature presents problems. Roman has two meanings: one describing a letter based on fifteenth-century Italian letterforms, and the other representing an upright letter, as opposed to a sloped, or italic, letter. The result of such loose phraseology is a popular contemporary typeface, Times Roman Italic. No system can comfortably allocate every available typeface to a proper category. Some styles do not find a niche in a simplified system, and to be effective, any approach should remain as elementary as possible.

Perhaps a single example might suffice here. The widely used Lydian design (figure 30) of Warren Chappell, popular for half a century, is basically a sans serif type, but it is also a broad-pen construction and is obviously unrelated to the sans serif concept as represented by the traditional gothics or their geometric transformation. It might fit in the Decorative-Display listing, but should it require a new classification such as Broad-Pen, the methodology would only be complicated.

Some writers have suggested type *use* as a means of classification. Such a procedure certainly has its limitations, since most printing types can be used for many printing requirements. While a number of specialized types have been created for newspaper text, and therefore could be listed as "newspaper types," they would no doubt serve equally well for commercial printing.

The fundamental purpose of any type classification system is to simplify learning the disconcerting number of types available. Logical groupings in which certain structural changes limit the choice of category is one way to help the beginner. We must leave to mature typographic devotees the luxury of deciding the exact

placement of every design that has ever found its way to the printer's case, the composing machine matrix, the photographic grid, or to digitized computer storage.

It must not be forgotten that type is first of all a tool for communication and that a system of identification must aim at aiding the typographer in using it effectively for this purpose.

During my thirty years of teaching typography in the School of Printing of the Rochester Institute of Technology, I used the system of classification presented in this book. I am convinced that the procedures adopted have worked reasonably well, and that this simplified method of type recognition has been effective for learning the basic features of most available types. The sequence followed by a rational type classification procedure is necessarily historical and while a full discussion of the influences on type design belongs more properly in a history of printing rather than in a workbook, I will outline the selection process and explain the sequence it follows.

1.—Blackletter
2.—Oldstyle
 a.—Venetian
 b.—Aldine-French
 c.—Dutch-English
3.—Transitional
4.—Modern
5.—Square Serif
6.—Sans Serif
7.—Script-Cursive
8.—Display-Decorative

In this book italic types are not listed separately from roman types. The italic form, designed in 1501 for the Venetian printer-publisher, Aldus Manutius (figure 31), was used for the more economic composition which a narrower letter could provide. For some forty years the italic, or sloped, form was simply another style of type, and it was the French punchcutters—Claude Garamond in particular—who consciously styled an italic from a roman model.

Today most roman types have "matching" italics which closely resemble the roman, or upright form. The two-letter matrix of the linecasting machine has contributed to this design concept. It is

P·V·M· GEORGICORVM,
LIBER QVARTVS·

Rotinus aerii mellis, cœleſha dona

P Exequar, hanc etiam Mœcœnas aſpice
partem.

Admiranda tibi leuiũ ſpeⱪacula rerũ,

M agnanimos´q; duces, totius´q; ex ordine gentis

M ores, et ſtudia, et populos, et prælia dicam.

I n tenui labor, at tenuis non gloria, ſi quem

N umina lena ſinunt, audit´q; uocatus Apollo·

P rincipio, ſedes apibus, ſtatio´q; petenda,

Q uo neq; ſit uentis aditus (nam pabula uenti

F erre domum prohibent) neq; oues, hœdi´q; petula

F loribus inſultent, aut errans bucula campo

D ecutiat rorem, et ſurgentes atterat herbas.

A bſint et piⱪi ſqualentia terga lacerti

P inguibus à ſtabulis, meropes´q;, aliæ´q; uolucres,

E t manibus progne peⱪus ſignata cruentis.

O mnia nam late uaſtant, ipſas´q; uolantes,

O re ferunt, dulcem nidis immitibus eſcam·

A t liquidi fontes, et ſtagna uirentia muſco

A dſint, et tenuis fugiens per gramina riuus,

P alma´q; ueſtibulum, aut ingens oleaſter obumbret,

V t cum prima noui ducent examina reges

V ere ſuo, ludet´q; fauis emiſſa iuuentus,

V icina inuitet decedere ripa calori,

O buia´q; hoſpiciis teneat frondentibus arbos.

I n medium, ſeu ſtabit iners, ſeu profluet humor

T ranſuerſas ſalices, et grandia coniice ſaxa

31. Virgil, printed by Aldus Manutius in italic type (1501)

interesting to note the direction taken in italics design to accompany contemporary revivals of the fifteenth-century and Venetian types. Since prior to 1501 there were no italic types to match the romans, the designer had to create his own style. Thus many Venetian types currently available have italics in what is sometimes called Chancery style. These italics, narrower and more angular than standard italic forms (figure 32), are derived from styles created by early sixteenth-century writing masters. They are greatly admired as examples of that splendid period.

While not all Venetian Oldstyle types have Chancery italics, all

PERHAPS THE FINEST W

Perhaps the finest writing in all h

32. *Deepdene, designed by Frederic W. Goudy; a Chancery italic*

Chancery italics have been designed to accompany Venetian Old-styles. Some fine examples are Deepdene, Palatino, Bembo, and Weiss Roman. In two well-known instances, the matching italics for romans bear different names. Centaur, designed by Bruce Rogers, has for its italic a Chancery named Arrighi, designed by Frederic Warde. The English Monotype Poliphilus is comple-mented by an italic named Blado.

While most italic types are cursive variants of the roman, there have been several attempts to provide an italic form closer to the original. These attempts have been prompted by readers' difficul-ties with all-italic composition. Some designers have replaced a true italic with "oblique" romans which normally keep the roman form in all letters and employ but a slight angle. (See figure 33).

While the resulting italic is more legible set in text, it lacks the emphasis of currently used italics. The American type-designer William A. Dwiggins supplied an oblique italic for his successful type, Electra. It was originally well-received, but later he found it necessary to supply a normal italic. The Linotype firm distin-guishes between the two, calling the second italic cursive. Such styles as the uncials (figure 34), which are revivals of letterforms of the sixth to the eighth centuries, predating the Carolingian minuscules, which were forerunners of the romans, cannot be properly classified in a system beginning with the fifteenth cen-tury. Since just a handful of uncial types (Libra, Hammer, Uncial, Solemnis) are in everyday use outside of Ireland, a special cate-gory for them is unnecessary. In this book they are placed under Blackletter, which seems closest to the spirit of the uncial form.

Still another listing, often confusing to a beginner, yet logical to the experienced typographer, is Twentieth Century Romans, or Contemporary Romans. In this category are many popular con-temporary types, such as Times Roman and Electra. The difficulty here is that if we assume that type classification begins with letter structure which has evolved historically over the past five centu-

ABCDEFGHIJKLMNOPQRST
abcdefghijklmnopqrstuvwxyz

33. Romulus, designed by Jan van Krimpen; an oblique italic

of all the world's gre

34. Libra, an uncial type designed by S. H. De Roos

ries, then it is unwise to turn to an irrational basis for judgment such as how a type is used, or the particular period when it was designed. A modern type designer creating a new letter has naturally been influenced by all the preceding types, and unless he is deliberately going back to a specific period, he will produce a type which inevitably contains features of those historic types he admires. In most cases his type will fall naturally into the Transitional classification.

Blackletter

The first movable types were exact copies of the manuscript hand of fifteenth-century German. Europeans properly call these first types Gothic, but terminology problems developed when in the United States this name was assigned to the early sans serif types of the 1830s. An argument against using the term Blackletter is that it could mean simply a description of a bold-faced character. A possibility to consider is assigning the name textletter to this first group, but here again there is difficulty. Although early gothic manuscript lettering was called *textura* by the Italians (describing the woven appearance of closely spaced heavy letters), the name textletter can be misconstrued as a type used for body-matter composition; printers commonly separate types for display and types for text.

Probably the most common name for this style of type is Old English, but this term specifies a single model of blackletter rather than a whole group. The term Blackletter, therefore, repre-

35. *Blackletter—ATF, Cloister Black, similar to the type used by Gutenberg on his 42-line Bible. The design of the type was based on the broad pen letter used by German scribes of that period.*

the sentence of appreciation, the deed of loving kindness. Do with a will what your hand finds to do, today, while it is light; for the night cometh, when no man can work. We know that we can pass this way but once. Put your good resolutions consistently into effect today.✠

36. *Cloister Black*

sents at best a reasonable solution. While few blackletter types are in wide use in the United States, the style has had a long history, and the serious student of printing types must learn several subdivisions of the classification if he is to recognize the many historic models.

The first group, Textura, or simply Text, includes types which are quite squarely drawn and almost completely lacking curves. Daniel B. Updike, in his authoritative *Printing Types*, calls the Textura a *lettre de forme*. In its modern revival, it is closely related to the type of Johann Gutenberg, as shown in the great 42-line Bible (figure 35). Two versions of Textura commonly used by American printers are Cloister Black and Goudy Text. The former is a typical "Old English" design (figure 36), while the Goudy design is notably condensed and is therefore somewhat closer to the original fifteenth-century blackletter types (figure 37).

Prosperous and Healthy Eastern Airport Is Repaired

37. *Goudy Text with Lombardic Initials*

Another subdivision of blackletters is Gothic-Antique. Updike calls it *lettre de somme*, and it is a little less formal than Textura. As the name suggests, there is a mixture of two styles in this form. By American terminology we would call it Blackletter-Roman, but the European term is now so widespread that a change would be confusing. Gothic-Antique types are rounder and less angular than the original blackletter, and most of the vertical strokes lack "feet" or ending strokes. The tendency toward roundness is a roman characteristic, which makes the style more legible to modern readers.

A third group of blackletters is Rotunda, or Round Gothic. Both this form and the Gothic-Antique are listed by some typographic scholars as *Fere-Humanistica*, and there is no single authority in the matter. The Rotunda is basically the Southern European blackletter and consequently much closer to the roman tradition than is the Textura. An added advantage of Rotunda over Textura is its more legible capitals. An excellent Rotunda available to printers in this country is Goudy Thirty, the last of the many types of the great designer issued by the Monotype Company.

The last subdivision of Blackletter is Bastarda, or *lettre bâtarde*. This form has long been the principal German vernacular type, particularly in the Fraktur designs which were first cut in the early sixteenth century. Fraktur, or "broken" type, is a lighter and more open version of Textura, with many added flourishes in both capitals and lowercase letters. Although supplanted by roman in much German printing since World War II, Fraktur is still widely used.

The use of blackletter has declined in the United States except for occasional use in liturgical printing and other church-related production. It also survives in the printing of certificates, diplomas, and resolutions. Unquestionably the last great stand of blackletter is in the flags, or nameplates, of hundreds of American newspapers.

Oldstyle—Venetian

It was not until twenty-five years after the introduction of printing in Germany that the first printers began to practice their craft in Italy. In 1465, Conrad Sweynheim and Arnold Pannartz set up a printing office in the monastery of Subiaco, near Rome, and

produced the first book printed in a style of type favored by the Italian scholars and which was given the name roman. The Subiaco letter, however, contained a number of gothic characteristics, because the printers had learned their trade in Germany and were not skilled in cutting roman type.

During the fourteenth century, the Italian humanist scholars had returned to the ninth-century Carolingian minuscule as a model for a book hand with which to re-copy the ancient manuscripts. The humanist tradition in writing was so well established that the northern manuscript hands were ill-favored and the early printers soon adapted to the demand for the roman style. Within a few years the gothic influence waned. The most notable early roman type is that of Nicolas Jenson, a Frenchman who established himself in Venice in 1470.

Venice quickly became the principal center of printing activity, due primarily to its location and its importance in world trade. As the Venetian presses produced the greatest volume of printing in Italy in the period up to 1500, their types became well known and subsequently widely copied in northern Europe. Modern cuttings of these letters are now called Venetian Oldstyle. The characteristics to be noted in the Venetian types are uneven, or slightly concave serifs, and the minimal contrast between thick and thin strokes. The crossbar of the lowercase "e" is slanted, and on certain capitals—N, M, and sometimes A—there are slab serifs which extend across the tops of the upright strokes.

The modern revival of fifteenth-century Italian types occurred about 1890 influenced by the private press movement, in both Europe and the United States. William Morris, the English craftsman and poet, became greatly excited about printing. He decided in 1888 to produce a type of his own and to set up a printing office where he could make books in the spirit of those of the incunabula period between 1440 and 1500.

As a model, Morris selected a type of the Venetian printer, Jacobus de Rubeus, which was a somewhat heavier version of a Nicolas Jenson type. Morris then photographed the letters in enlargement. The finished type, cut by the skilled punchcutter Edward Prince, was in the spirit of the Jenson original, but tended, as Morris later wrote, "rather more to the Gothic than does Jenson's." The new design—Golden type—was intended for an edition of *The Golden Legend*, the first book scheduled to be printed by Morris' Kelmscott Press (see figure 38). The highly successful

through the streets of Micklegarth, and hedged
with their axes the throne of Kirialax the Greek
king, it was alive & vigorous. When blind Dan-
dolo was led from the Venetian galleys on to the
conquered wall of Constantinople, it was near to
its best & purest days. When Constantine Palæo-
logus came back an old and care-worn man from
a peacefuller home in the Morea to his doom in
the great city, and the last Cæsar got the muddle
.of his life solved, not ingloriously, by Turkish
swords on the breached and battered walls of
that same Constantinople, there were signs of
sickness beginning to show in the art that sprang
from there to cover east and west alike with its
glory.
And all that time it was the art of free men. What-
ever slavery still existed in the world (more than
enough, as always) art had no share in it; & still
it was only here & there that any great names rose
above the host of those that wrought it. These
names (& it was mainly in Italy only) came to the
front when those branches of it that were the work
of collective rather than individual genius, archi-
tecture especially, had quite reached their highest
perfection. Men began to look round for some-
thing more startlingly new than the slow, gradual
change of architecture & the attendant lesser arts
could give them. This change they found in the glo-
rious work of the painters, & they received it with
an out-spoken excitement and joy that seems

*38. The Golden Type of William Morris from
"Art and the Beauty of the Earth," Chiswick Press (1899)*

ARLY, while yet the
dark was gay
And gilt with stars,
more trim than day,
Heav'n's Lily, and the
earth's chaste Rose,
The green immortal
Branch, arose, *

And in a solitary place
Bow'd to His Father His bless'd face.

If this calm season pleas'd my Prince,
Whose fulness no need could evince,
Why should not I, poor silly sheep,
His hours, as well as practice, keep?
Not that his hand is tyed to these,
From whom time holds his transient lease;
But mornings new creations are,
When men, all night sav'd by His care,
Are still revived; and well He may
Expect them grateful with the day.
So for that first drawght of His hand,
Which finish'd Heav'n, and sea, and land,
The Sons of God their thanks did bring.

* S. Mark, c. i. v. xxxv.

39. The Vale Type: from the Vale Press Edition of
The Sacred Poems of Henry Vaughn

Kelmscott Press prompted numerous other amateurs to enter the field of printing, and additional private types quickly appeared. Many in the spirit of the Golden type were bold romans which set up into the virile, black pages Morris favored. Examples are the types of the Vale Press (figure 39), Essex House Press, and Merrymount font produced for Daniel B. Updike's Merrymount Press in Boston.

In 1899, T. J. Cobden-Sanderson, an amateur bookbinder, who had bound several of the Kelmscott volumes, established his own

This is the supreme Book Beautiful or Ideal Book, a The Ideal Book
dream, a symbol of the infinitely beautiful in which
all things of beauty rest and into which all things of
beauty do ultimately merge.
❡ The Book Beautiful, then, should be conceived of
as a whole, & the self-assertion of any Art beyond the
limits imposed by the conditions of its creation should
be looked upon as an Act of Treason. The proper
duty of each Art within such limits is to co-operate
with all the other arts, similarly employed, in the pro-
duction of something which is distinctly Not-Itself.
The wholeness, symmetry, harmony, beauty without
stress or strain, of the Book Beautiful, would then be
one in principle with the wholeness, symmetry, har-
mony, and beauty without stress or strain, of that
WHOLE OF LIFE WHICH IS CONSTITUT
ED OF OURSELVES & THE WORLD, THAT
COMPLEX AND MARVELLOUS WHOLE
WHICH, AMID THE STRIFE OF COMPETI
TIVE FORCES, SUPREMELY HOLDS ITS
OWN, AND IN THE LANGUAGE OF LIFE
WRITES, UPON THE ILLUMINED PAGES
OF THE DAYS, THE VOLUMES OF THE
CENTURIES, & THROUGH THE INFINIT
UDES OF TIME & SPACE MOVES RHYTH
MICALLY ONWARD TO THE FULL DEVE
LOPMENT OF ITS ASTONISHING STORY
THE TRUE ARCHETYPE OF ALL BOOKS
BEAUTIFUL OR SUBLIME.

40. Doves Type from The Ideal Book,
by T. J. Cobden Sanderson (1900)

press. He, too, adapted an original type of Nicolas Jenson. His
design, called the Doves type (figure 40), after the name of the
press, was of lighter weight and closer to the spirit of Jenson. It
was used most successfully for over fifteen years, and greatly in-
fluenced the direction of the revival of Venetian types.

The Golden type of Morris was widely imitated by commercial
typefounders in Europe and America under such names as Jen-
son and Kelmscott, but these copies accented the eccentricities of

ABCDEFGHIJKLM NOPQRSTUVWXY

How is one to assess abcd efghijklmnopqrstuvwxy

41. Oldstyle (Venetian)—The Centaur type, a letterform inspired by Italian Renaissance roman types which followed the humanistic manuscript styles, which were in turn based on ninth-century Carolingian minuscule forms. Designed by Bruce Rogers for the Metropolitan Museum of Art, it was inspired by the type of Nicolas Jenson, the fifteenth-century Venetian printer.

the design when manufactured in display sizes. The first type completely acceptable as a modernized Venetian was Cloister Oldstyle designed by Morris Benton for American Type Founders Company in 1913. (See figure 41.) Cloister Oldstyle is still widely used. Following the success of Cloister, many other designers were attracted to the Venetian period. The American typographer, Bruce Rogers, drew Centaur, which has long been considered one of the finest roman types ever cut (figure 42). Frederic W. Goudy, the most widely known American type designer, returned again and again to Italian forms with great success in such types as Forum, Kennerley, Deepdene, and Californian (now called Berkeley Oldstyle).

The strong influence of William Morris is felt even today, for his efforts to improve the making of books produced a renaissance in the art of the book. As collectors and bibliophiles became more interested in fine printing, there was an insistent demand for better types—a profound benefit to printers everywhere.

Oldstyle types of Venetian origin are presently more available than any of the later Oldstyle variations. That current designers continue this tradition is evident in such types as ITC Italia and ITC Benguiat.

ABCDEFG
HIJKLMNO
PQRSTUV
WXYZ&
abcdefghijklmn
opqrstuvwxyz
.,-:;!?'"fiffflffffiffl
1234567890$

42. *Centaur*

Oldstyle—Aldine-French

The earliest types were conscious copies of hand-written characters. The printers were so anxious to emulate the scribes, they even adopted the numerous tied letters, or ligatures, the scribes resorted to when approaching the end of a line. The original Gutenberg fonts, for example, contained forty or more of these tied letters. However, the steel tools of the punchcutters were far removed from the reed-pens of the scribes. They soon refined the form of their letters, depending less on the pen-drawn characters.

Francesco Griffo da Bologna, probably the most skillful Italian punchcutter of the period, produced types for the great Venetian publisher and printer, Aldus Manutius. Since Aldine books were in wide demand because of their authoritative scholarship, their types were copied by printers all over Europe, particularly in France, where roman types were highly regarded.

Griffo types improved upon earlier Venetian models—the contrast of stroke was more pronounced, slab serifs were dropped, and the crossbar of lowercase "e" became straight. This change in structure prompted British typographers to consider that Griffo's designs marked the beginning of a classification they call Old Face, a designation including all the roman types developed between 1495 and 1720.

Many twentieth-century types have been adapted to the concepts of the Griffo designs, but do not represent such close copies as Bembo and Poliphilus adapted for monotype composition in the 1920s. Probably the most widely known of these at present is the very popular Palatino, designed by Hermann Zapf in 1948. It is the type used for the text of this book. Another variation of the form is Goudy Oldstyle, cut by Frederic W. Goudy in 1915, and still very much in evidence, particularly in the boldface version, which was produced by the foundry rather than by the designer himself.

In the system of classification suggested in this book, Aldine types are grouped with the sixteenth-century French types they undoubtedly influenced. One difficulty in any attempt to precisely classify historic types is that designers of modern cuttings of these letters frequently take artistic license in their adaptations. Even types bearing the same name but produced by different typefounders or composing machine manufacturers, differ from letter to letter. A further complication in such modern cop-

Itaq̃,quaspueri miferimusadtelucubra
tionesnoftras;numerare aliquas poffu-
mus; quas adolefcentes,non poffumus :
quo in confilio nobis diutius permanen
dum effenon puto: nam ut interdum nó
loqui moderati hominis eft; fic femper
filerecum eo ,quem diligas, perignaui:
neq̃; Hercule; fi in officio permanfimus
in prima aetate ; debemùs nunc , tanq̃
inexercitati hiftriones ,in fecundo , aut
tertio actu corruiffe. praefertim cum
aemulatio tuorum ftudiorum Angéle
nosnon excitaremodo languentes poffit,
fedetiam incendere;quippe , qui multa,
et praeclara habuimus a te femper,habe
mùfq̃; quotidie etconfuetudinis noftrae
teftimonia, et doctrinaetuae. Quare fi
cuti pueri fcriptiunculasnoftras, quafi la
ctentis ingenii acerbitatem , detulimus
ad te; ficnuncdeincepsetiam ad te adole
fcentiaenoftrae primosfoetusdeferemus;
non quo me ipfe plusames: nam iam id

43. Page from De Aetna by Petro Bembo;
printed by Aldus Manutius (1495)

ies is the need to produce types to meet the requirements of con-
temporary printing production methods. Until the nineteenth
century, all printing was produced on handpresses with hand-
made paper. Punchcutters therefore turned out types that would
print clearly and openly when subjected to pressures necessary
to produce an image. Changes in printing processes brought
about subtle changes of letterforms adaptable to new techniques
of printing.

SELECT A STRIPE, A FLORAL,
Design In Correlated Colors. We
to cut the fabric over the furniture

44. Bembo

*Far too often people having completely read
it aside without ever realizing the excellent*
ABCDEFGHIJKLMNOPQRST

45. Poliphilus

Griffo produced two types for Aldus which are of great impor-
tance in the ultimate development of oldstyle faces. The first,
which appeared in an edition of *De Aetna* (figure 43), by the hu-
manist scholar Pietro Bembo, was cut in 1495. The modern adap-
tation of this fine letter, named Bembo (figure 44), was produced
in the 1920s as part of the program of the English Monotype firm
to revive a number of the best historic types. The typographic
historian, Stanley Morison, was responsible for this estimable ef-
fort to improve the types manufactured for the composing ma-
chine.

For the *Hypnerotomachia Poliphili* of 1499, Aldus used a different
version of the *De Aetna* letter. This illustrated book, one of the
most important volumes produced during the Renaissance, pro-
moted wide interest in the Aldine types. It also has been cut by
the English Monotype Company under the name of Poliphilus
(figure 45).

During the sixteenth century, Italian contributions to the art of
typography declined, but in France, a most fortunate combina-
tion of circumstances produced both the need for scholarly print-
ing and men with the skill and imagination to take advantage of
it. The Estienne family, encompassing three generations, Geofroy

46. Oldstyle (Aldine-French): ATF Garamond, based on the classic oldstyle let-ter—clear, open, and graceful—designed and cut by Claude Garamond. Types based on his design were cut by practically every foundry in the Western world.

Tory, Claude Garamond, Robert Granjon, and other artists and craftsmen brought to France what most typographical historians have called a golden age of typography.

Both these craftsmen and leading scholars of the period were greatly influenced by the roman types of the Italian printers in the production of classic literature. Aldine types were particularly admired and widely copied. French adaptations of the Italian letters predominated in France and other European countries for almost a century and a half. The modern revival of these French romans centers upon the designs of Claude Garamond, best known of the sixteenth-century punchcutters (see figures 46 and 47). Garamond achieved renown for a font of Greek types, and later cut a roman based upon the font produced for Aldus by Francesco Griffo. An important innovation by Garamond was the design of an italic which was a consciously formed complement of the roman. Previously, italics had been considered as independent cursive types, following the first one, which was produced for Aldus in 1501.

After Garamond's death in 1561, his punches were widely scattered. Christopher Plantin, one of the great scholar printers, purchased a number of fonts which remain in his Antwerp printing office, now the Plantin-Moretus Museum. Another important purchaser of the Garamond punches was the Egenolff-Berner typefoundry in Frankfurt which showed the types in the earliest known typefounder's specimen sheet, dated 1592 (figure 48).

The principal sources of present-day Garamond types are punches engraved in a similar style about 1621 by the French printer, Jean Jannon of Sedan (figure 49). Jannon was printer to a Protestant academy whose typefounding equipment was impounded by Cardinal Richelieu for use in the newly established *Imprimerie Nationale*. Jannon types were first used in Richelieu's own work, *Principaux Points de la Foi*, printed in 1640. The types apparently were not used again until revived by the same French National Printing Office in a specimen showing of 1845 and were mistakenly attributed to Claude Garamond. In 1900, the types were again used in a history of the printing office, and it is this printing which inspired their revival by Morris Benton and T. M. Cleland for American Type Founders Company in 1917. The Benton copy was an immediate success, and it prompted a number of other adaptations of both the Jannon type and the earlier Garamond types.

ABCDEFGHI JKLMNOPQR STUVWXYZ

abcdefghijklmn opqrstuvwxyz

1234567890$£

47. *Garamond*

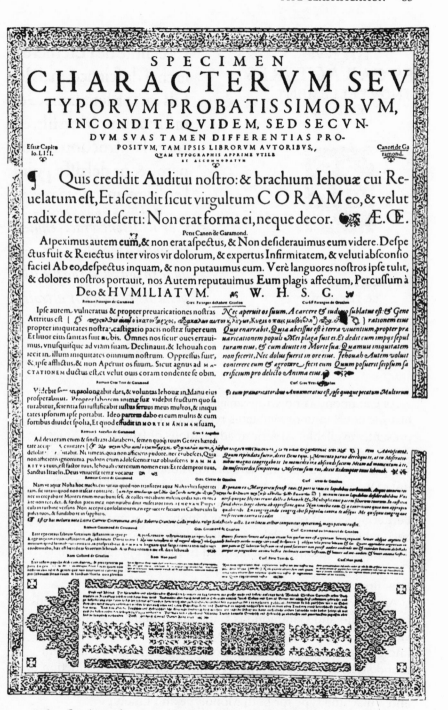

48. *Specimen sheet issued by Egenolff-Berner Foundry, Frankfurt (1592)*

ESPREVVE
DES CARACTERES
NOVVELLEMENT
TAILLEZ.

A SEDAN,
Par Iean Iannon Imprimeur
de l'Academie.
M. DC. XXI.

GROS CANON.
La crainte de l'Eternel eſt
le chef de ſcience: mais les
fols meſpriſent ſapiéce &
inſtruction. Mon fils, eſ-
coute l'inſtruction de ton
pere, & ne delaiſſe point
l'enſeignemēt de ta mere.
ITALIQVE GROS CANON.
Car ils ſeront graces enfilees
enſemble à ton chef, & car-
quans à ton col. Mon fils,ſi les
pecheurs te veulent attraire,
ne t'y accorde point.

49. Specimen book issued by Jean Jannon, Sedan (1611)

As Garamond is now universally accepted, a knowledge of its historic development facilitates recognition of the various cuttings presently available. American adaptations of Jannon are American Type Founders Garamond, Linotype Garamond No. 3 (figure 50), Monotype American Garamond, Monotype Garamond (figure 51), and Intertype Garamond. The Garamond of the Ludlow Typograph Company is based on that shown in the Egenolff-Berner Specimen of 1592, as is the Linotype Garamond (no number), which is also available in a founder's version from Stempel in Frankfurt. Another type adapted from this 1592 specimen is Granjon (figure 52), cut by George W. Jones for the British Linotype firm.

An interesting recent revival resulting from a deliberate blending of Griffo and Garamond is Garaldus, designed by Aldo Novarese for the Italian foundry Nebiolo in Turin. In 1960, the well-known typographer, Jan Tschichold, cut a variation of the Garamond style, called Sabon (figure 53), which had the distinction of being simultaneously available as a foundry type for Stempel, and a machine type for both Monotype and Linotype.

abcdefghijklmnopqrstuvwxy
ABCDEFGHIJKLMNOPQ

50. Linotype Garamond No. 3

THE CLASSES OF CO
The classes of compositi

51. Monotype Garamond

ABCDEFGHIJKLMNOPQ
abcdefghijklmnopqrstuvwxy

52. Linotype Granjon

ABCDEFGHIJKLMNOPQRSTUVWX
abcdefghijklmnopqrstuvwxyz 123456

53. Sabon

Dubbelde Paragon Capitalen.
Paragon à deux Points.

ABCDE
FIGHJK
LMNOQ
RSWZÆ

Dubbelde Text Capitalen.
Petit Paragon à deux Points.

ABCDEFI
HJKLMSZ
GNOPQR,,

54. *Dutch type, from Specimen book of Enschedé Foundry, Haarlem (1768)*

Distinguishing features of the Garamond types are wide concave serifs, particularly in the cap font. There are a number of individualized features in the capitals of several of the Garamonds now being used. The lowercase, however, adheres more consistently to the original, as in the remarkably small counter space in "a" and "e," a noticeable feature in almost all of the adaptations.

Oldstyle—Dutch-English

During the sixteenth century, French types were greatly favored throughout Europe, but after a hundred years their popularity gave way to those of the Low Countries. As Holland was a principal trading nation during the seventeenth century, Dutch printers became increasingly important, and it is through their efforts that the roman types called oldstyle acquired their final forms.

Although the Dutch press of this period hardly contributed to the art of the book, and produced no printers like Simon de Colines, Jean de Tournes, and the Estiennes, it nevertheless can be credited with the development of types. These were not as esthetically pleasing as the French letters, but were more practical for the everyday production of commercial printing. The contrast between thick and thin strokes was increased, but the serifs were straightened and in the lowercase fonts strengthened with almost wedge-shaped fillets, or brackets (figure 54).

An important factor in the dissemination of Dutch types was their acceptance in England, where typefounding was an unimportant craft. English dependence upon Dutch types lasted until the 1720s when William Caslon established his famous typefoundry in London. Originally an engraver, Caslon was persuaded to cut punches for a font of type about 1720. He was soon the most important and accomplished of the English founders, and except for the period 1800–1850, Caslon has been a standard type throughout the world. (see figures 55 and 56).

Colonial America naturally depended upon English printing supplies, and it was not until 1796 that the first independent and fully successful typefoundry was established. Before this, types cast by the Caslon foundry and its competitors were standard American stock. Today there are many cuttings of Caslon available. Most have been drawn in the last hundred years, but there are several close copies of the original design. The Stephenson Blake foundry of Sheffield, England, has the most authentic ver-

55. Oldstyle (Dutch-English): ATF Caslon 471, derived from the type letter cut by William Caslon, English typefounder of the eighteenth century. Note the contrast between thick and thin strokes as compared to the more even, graceful character of Garamond. Also note the unique apex of capital "A."

ABCDEFGH
IJKLMNOPQ
RSTUVWX
YZ&
abcdefghijklm
nopqrstuvwx
yz $1234567890

56. *Caslon*

A SIZE TYPICAL
of the earlier Janson.

57. Janson

sion, as it still possesses the punches and matrices prepared by the Caslon firm in the eighteenth century.

Some typographers argue that Caslon types truly represent the first commonly used typefaces which can be classified as transitional letters rather than as oldstyle. Certainly this is a reasonable claim, as the Caslon serifs tend to be straight-edged, and the contrast of stroke is pronounced. However, the lowercase serif structure retains a strong dependence upon the earlier Dutch forms, and a number of characters are definitely related to the same source. It seems therefore more practical to list Caslon as a Dutch-English oldstyle, representing the furthest development of the oldstyle form which began with the Venetian types of the fifteenth century.

Aside from the many versions of Caslon, the principal revival (in metal types) of a Dutch type is that of Janson (figure 57). This widely used type was originally cut by a Hungarian printer, Miklós Kis, about 1685, but mistakenly attributed to the Dutch printer, Anton Janson. Although similar in construction to Caslon, Janson is slightly heavier and under modern printing procedures provides a more solid book page than the English type (although, as noted in the discussion of digitized types, it has not fared so well).

Transitional

The development of types called Oldstyle took almost two hundred and fifty years, but within a half century following the introduction and dissemination of the types of William Caslon, roman letters underwent profound changes in structure, due to both esthetic and technical influence. The term transitional describes

types with characteristics based on the oldstyle fonts, coupled with features of the type style called modern.

The first significant attempt to re-design the oldstyle letters occurred in France in 1693, when a committee directed by the Académie des Sciences undertook to create an improved typeface. The resulting type was the *romain du roi, Louis XIV,* and was cut by Philipe Grandjean (figure 58). Its first use was in the *Medailles de Louis XIV,* published in 1700. The *romain du roi,* however, became the property of the *Imprimerie Royale,* the French national printing office, and was not available to commercial printers. Although criticized in its own time, the font was a notable departure from existing types, featuring strong stroke contrast and straight, sharp serifs with very little bracketing. In 1742, the typefounder Pierre Simon Fournier *le jeune* published a specimen book *Modeles des Caractères de l'Imprimerie,* showing types obviously derived from *romain du roi* (see figure 59).

The eighteenth-century type considered by most authorities to represent the real beginning of the transitional form, however, was that of John Baskerville, an amateur printer who set up a printing office in Birmingham, about 1750. Baskerville introduced a number of technical innovations in his printing, most of which affected the appearance of his types. He knew and respected William Caslon and his types, but he felt he could improve upon them.

Baskerville's press was more solidly constructed than those of his fellow printers. He used a brass plate and favored a hard impression at a time when a cushioned squeeze was preferred. He also instituted the practice of passing printed sheets through heated copper cylinders to smooth the rough-textured paper then commonly used. Typographically, Baskerville was fond of wide margins and well-leaded pages, another departure from the style of his day (see figure 60).

Although his efforts were unsuccessful in England, Baskerville was enthusiastically received by European craftsmen, and he produced a type which has since become a universal favorite.

Following Baskerville's death in 1775, his types were copied and their influence may be observed in several other English types cut before 1800. (See figure 61.) The letter made for the publisher John Bell in 1788 by the punchcutter Richard Austin is a fine example of a Baskerville-derived type, as is the famous type

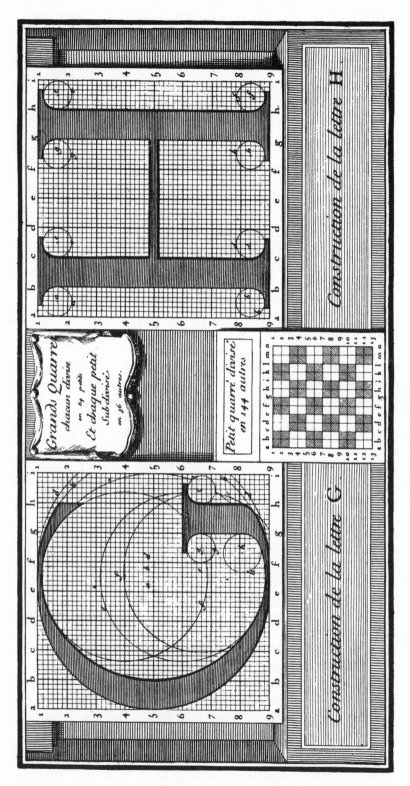

58. *Romain du Roi* of Grandjean (ca. 1700)

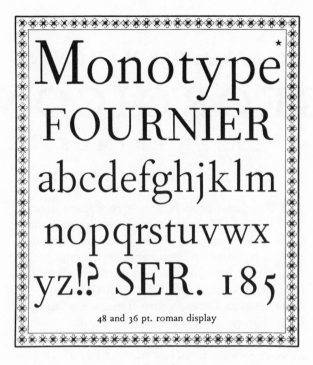

Monotype*
FOURNIER
abcdefghjklm
nopqrstuvwx
yz!? SER. 185

48 and 36 pt. roman display

59. Fournier type

of the Shakspeare Press of William Bulmer (see figure 62). This distinguished letter, designed by William Martin, first appeared in 1791 after the introduction of the French Didot types of the Continental style but retains some of the warmth of the oldstyle heritage.

The logical development of the transitional style may be traced through the nineteenth-century Scottish types to Scotch Roman of the early 1900s (figure 63). Caledonia, designed for Mergenthaler Linotype Company by William A. Dwiggins in 1939, still demonstrates the effect of this influence and is one of the most popular book types presently available. In Caledonia (figure 64), Dwiggins combined the concepts of Martin and Bodoni with the legibility features of Scotch Roman to produce a type which ideally meets current typographic standards.

Thus, transitional types have continued the historical developments begun with the *romain du roi*. A group of transitional types which can be set apart from this historic line of development are

P. VIRGILII MARONIS
GEORGICON.
LIBER PRIMUS.

Ad *C. CILNIUM MAECENATEM.*

QUid faciat lætas fegetes, quo fidere terram
Vertere, Mæcenas, ulmifque adjungere vites
Conveniat: quæ cura boum, qui cultus habendo
Sit pecori, atque apibus quanta experientia parcis,
5 Hinc canere incipiam. Vos, o clariffima mundi
Lumina, labentem cœlo quæ ducitis annum,
Liber, et alma Ceres; veftro fi munere tellus
Chaoniam pingui glandem mutavit arifta,
Poculaque inventis Acheloia mifcuit uvis:
10 Et vos agreftum præfentia numina Fauni,
Ferte fimul Faunique pedem, Dryadefque puellæ:
Munera veftra cano. Tuque o, cui prima frementem
Fudit equum magno tellus percuffa tridenti,
Neptune: et cultor nemorum, cui pinguia Ceæ
15 Ter centum nivei tondent dumeta juvenci:
Ipfe nemus linquens patrium, faltufque Lycæi,
Pan ovium cuftos, tua fi tibi Mænala curæ,
Adfis o Tegeæe favens: oleæque Minerva
Inventrix, uncique puer monftrator aratri,
20 Et teneram ab radice ferens, Silvane, cupreffum:
Dique Deæque omnes, ftudium quibus arva tueri,
Quique novas alitis non ullo femine fruges:
Quique fatis largum cœlo demittitis imbrem.

Tuque

60. Latin Virgil, printed by John Baskerville (1757)

ABCDEFGH
IJKLMNOP
QRSTUVW
XYZ&
abcdefghijkl
mnopqrstuv
wxyz
$1234567890

61. *Baskerville of Stephenson-Blake*

62. *Transitional: ATF Bulmer, taken from the letterform designed by William Martin in 1791. Appears more precise, and mechanically designed, than the old-style romans that have the roughness and idiosyncrasies of handhewn letters.*

ABCDEFGHIJKLMNOPQRSTU
VWXYZ
abcdefghijklmnopqrstuvwxyz

63. Scotch

ABCDEFGHIJKLMNOPQRST
UVWXYZ&
abcdefghijklmnopqrstuvwxyz

64. Caledonia

ABCDEFGHIJKLMNOPQRSTUV
WXYZ
abcdefghijklmnopqrstuvwxyz

65. Century Expanded

ABCDEFGHIJKLMNOPQRSTUV
WXYZ
abcdefghijklmnopqrstuvwxyz

66. Century Schoolbook

ABCDEFGHIJKLMNOPQRSTUV
WXYZ
abcdefghijklmnopqrstuvwxyz789!,$&?

67. Cheltenham

"legibility" types. They are primarily specialized letters which are used for newspaper printing, with one or two notable exceptions. The earliest type of this genre was Century (figures 65–66), designed for *Century Magazine* in 1895 by Linn Boyd Benton with the collaboration of Theodore L. De Vinne. This type was produced to meet the standards of high-speed quality printing—counter spaces were open, the x-height large, and serifs were even and strongly bracketed.

This basic concept was advanced during the 1920s by the Linotype and Intertype firms, both extremely active in the production of such types. In most instances these faces are available only in small sizes, rarely going beyond 10-point. They vary from one another in weight principally, and have few characteristics which may be selected for ready recognition.

A third group of transitional types are those created simply as new examples of roman letters. When faced with the problem of turning out a new type, a contemporary type designer is invariably influenced by all the types he knows and admires. Unless he is seriously attempting to produce a specific period style, he is influenced by such a diversity of letterforms that he may very well create a transitional letter.

One transitional type, by the architect Bertram Goodhue, is Cheltenham, designed in 1896 (see figure 67). Within two decades it was available in a family of some two dozen variants and had become the most widely used American display type. Lovingly called "Chelt" by several generations of printers, it remains a standard type.

The transitional classification contains the largest number of types, for obvious reasons, and therefore presents to the novice more difficulties than other type groups.

The Times Roman design (figure 68), drawn to the specifications of Stanley Morison for *The Times* (the London newspaper), is in all probability the most widely used twentieth-century roman type. Although adapted from a type of Dutch origin, it fits the transitional classification.

Modern

The term Modern when used to describe a style of eighteenth-century type undoubtedly puzzles anyone attempting a logical

ABCDEFGHIJKLMNOPQ
RSTUVWXYZ
abcdefghijklmnopqrstuvwxyz

68. Times Roman

interpretation of typographic structure. But the literature of ty-
pography has in the last century so canonized the term that it
would be inconsistent to replace it with descriptions presently fa-
vored in the current European type classification systems, such as
Didone and Bodoni.

As noted above, *romain du roi* of Grandjean influenced type-
founders to reject the oldstyle types in favor of letters offering
greater contrast between thick and thin strokes. Narrower letters
replaced the full, round characters of the earlier types. Another
more important factor in type styling was the widespread interest
in copperplate engraving, encouraging types which were imita-
tive of the fine lines of the engraver's burin.

Baskerville's unique typographic innovations were enthusiasti-
cally accepted by Didot in France and Bodoni in Italy. Both cut a
variety of types, but the styles they are best remembered for are
those to which the term Modern is most commonly attributed. By
the middle 1780s Bodoni and Didot had cast and printed from
types which were, in the words of a critic, of "extreme dryness
and absolutely glacial rigidity of line." Bodoni's letters, while of
strong contrast, retained a very slight bracket in the structure of
the serifs (see figure 69). The Didot types imitated the engraver's
tool to an extreme—the light strokes became hairline, and the
serifs were completely unbracketed (figure 70).

Giambattista Bodoni, who began printing for the Duke of
Parma in 1768, earned the reputation of being the greatest printer
of his time. Since he was subsidized, he was in effect a private
printer, and had the enviable opportunity to print almost as he
pleased, without the competitive problems of his contemporaries.
When the types of this period were revived about 1910, they re-

69. *Page from Bodoni's* Manuale Tipographico, *Parma (1818)*

VINGT.

——•○○•——

Ego multos homines excellenti animo ac virtute fuisse, et sine doctrina, naturæ ipsius habitu prope divino, per seipsos et moderatos et graves exstitisse fateor : etiam illud adjungo, sæpius ad laudem atque virtutem naturam sine doctrina, quam sine natura valuisse doctrinam. Atque idem ego contendo, cum ad naturam eximiam atque illustrem accesserit ratio quædam conformatioque doctrinæ; tum illud nescio quid.

Tamen, hanc animi remissionem humanissimam ac liberalissimam

70. *Page from specimen of Fonderie de Firmin Didot, Paris (1828)*

71. *Modern: ATF Bodoni bears a greater resemblance to the stiff, brittle, me-chanical Didot types than to the types of Giambattista Bodoni. The extreme con-trast between thick and thin strokes and straight hairline serifs is indicative of this letter form.*

ceived the name Bodoni, although most re-cuttings favored the more mechanical characteristics of the Didot original (see figure 71).

The popular modern types quickly rendered the oldstyle romans obsolete as all founders followed the precepts of the Didot-Bodoni school. At this time there were other influences which brought about profound changes in the printing craft. At the moment when the modern style was completely accepted, the effects of the Industrial Revolution began to be felt. Up to the first decades of the nineteenth century, the dominant printer had been the book printer, but with the advent of industrial manufacturing and the subsequent need to promote the sale of goods, the commercial printer came into his own. Newspaper and periodical printing flourished and typefounders soon discovered that the new promotional techniques demanded new styles of type. Among the first types offered for this purpose were modifications of the modern style. The thick-thin contrasts, and the non-bracketed serifs, readily lent themselves to display characteristics so much in demand. The swollen versions of the modern face became known as fat faces, still so called in England. This letter is best known in the United States as Ultra Bodoni.

While the modern style of printing type proved effective for ephemeral printing, it had the opposite effect for book typography. The sparkling letters of Bodoni and Didot deteriorated into a variety of thin and characterless types, scarcely distinguishable from one typefoundry to the next. The display types, however, were so popular that founders increased their search for new forms. During the early twentieth-century revival of classic styles, most printers disparaged the nineteenth-century excesses in type design. More recently, however, many designers are looking to that period for inspiration.

Following the revival of Bodoni in 1909 by Morris Benton for American Type Founders Company (figure 72), the modern style has been extremely popular. The Didot types along with Walbaum, a German letter of 1800 (figure 75) have enjoyed a renaissance. There have been many types patterned on these historical models, utilizing the thick-thin contrasts and unbracketed serifs, but the originals are still very much in evidence for all typographic requirements.

The modern classification of type represents the fullest development of the roman letter which began with the late fifteenth-

ABCDEFGHIJKLMNOPQRS TUVWXYZ
abcdefghijklmnopqrstuvwxyz
1234567890 (.,:;!?""""-)*&$¢%/

72. Bodoni

INTRODUCING
biological science

73. ATF Bodoni Book

century Italian types and evolved through French and Dutch sources to the transitional forms of eighteenth-century England. Following the impact of the Industrial Revolution, type designers searched for new forms which, although based upon the style called roman, were sufficiently unique as to require new classification in order to be adequately described.

Square Serif

The first successful attack on the popularity of classic romans occurred in England. Vincent Figgins, the London typefounder who had introduced the first fat faces, showed in his specimen book of 1815 three sizes of a type called Antique. It was a bold-faced letter of monoline proportions which featured unbracketed serifs of the same weight as the main stroke. Antique was offered in a capital font only. In a few years this style of letterform was in wide demand.

The slab-serif, massively weighted types exactly suited the

abcdefghijklmnopqrstuvwxyz
ABCDEFGHIJKLMNOPQRSTUVWXYZ
!¡?¿%‰$¢£ƒ*†‡fifl&·ß§/ ÅåØøÆæ
1234567890 (.,:;" „ "- - —)‹›«»
[áçèñüšîãē]

74. Bauer Bodoni

abcdefghijklmnopqrstuvwxyz
ABCDEFGHIJKLMNOPQRSTUVWX
!¡?¿%‰$¢£ƒ*†‡fifl&·ß§/ ÅåØøÆ
1234567890 (.,:;" „ "- - —)‹›«»
[áçèñüšîãē]

75. Walbaum

needs of the new breed of job printers. They represent the earli-
est example of what is now commonplace in the design and mar-
keting of typefaces—originating a style to meet the requirements
of a specific set of circumstances. All printers did not happily ac-
cept the antiques. Certainly book printers looked with quizzical
eye at the wave of new styles which, as D. B. Updike wrote, so
quickly drove "original Caslon type to the wall." Updike, in his
great work *Printing Types, Their History, Forms, and Use,* had said
little about the square serif types, other than to quote denuncia-
tions of earlier writers. He showed none of them in his splendid
text, hoping, perhaps, that they might go away. But of course he
should have discussed them with the same dispassion he used
for the classic types.

About the same time that Figgins produced his first antique,
the typefounder William Caslon IV brought out a single mono-
tone cap font which he labeled Egyptian. Curiously, this term was
very soon applied to the slab-serif types, and is still used today. A
probable reason is that the block shape of the early industrial let-

76. *Square serif: Haas Clarendon, a redesigned cutting of a typeface, originated in the mid-nineteenth century. Used extensively during the 1950s and early 1960s in commercial and advertising typography, it is characterized by the heavy, squared-off and bracketed slab serifs.*

LIKE A NUMBER OF
his fellow country 789

77. *Stymie Medium*

abcdefghijklmnopqrstuv
ABCDEFGHIJKLMNOP

78. *Craw Clarendon Book*

ters superficially resembled Egyptian architecture in their solid, squared-off shape. Napoleon's conquest of Egypt aroused great popular enthusiasm for things Egyptian, and this interest happened to coincide with the introduction of the square serifs.

By 1825, slab-serif types were brought out with lowercase characters. Further experiments with the form produced serifs which were bracketed slightly, and by 1850 they were available in several weights and widths from all typefounders. Another modification was the slight degree of contrast which crept into the style, producing an altered form named Clarendon (figure 76).

The popularity of square serif types declined severely during the first three decades of the twentieth century, but the sans serif revival after 1926, along geometric lines, carried over to a renewed interest in similarly designed square serifs in such types as Memphis, Girder, Stymie, Cairo (figure 77), and Karnak. Although these styles were far removed from their nineteenth-century counterparts, the Egyptian terminology hung on.

The latest revival of the square serifs occurred about 1955, when all nineteenth-century types were being scrutinized by advertising agency typographers. The style selected for resurrection was Clarendon, since the geometric Egyptians were already labeled as "period 1930." Several successful Clarendons were cut (figure 78), and they are still widely used in commercial printing and advertising.

Sans Serif

The third style of type which emerged from the typefounders' confrontation with the Industrial Revolution and its specialized printing requirements was a letter without any serifs. It was the most radical typographical innovation since the invention of movable type itself. Before the early 1800s types were almost exclusively modeled on manuscript writing. The sans serif forms, however, had no historic precedent. Although some believe Roman coins inspired the sans serif, this can undoubtedly be discounted, as can the inscriptional sans serif lettering dating from the fifteenth-century which was probably unknown to the nineteenth-century founders. More likely, the success of Egyptian, or Antique, display letters led to experiments producing this ultimate simplicity in a printer's type.

The last specimen book produced by William Caslon IV, of the famous typefounding family, appeared in 1816. Buried within the decorative display types was a single line of monotone serifless capital letters stating "William Caslon Junr Letterfounder." This specimen was labeled, "two lines English Egyptian." This twisted bit of terminology anticipated the present confusion in typographic nomenclature. The term "English" was applied to the size now known as 14-point. Egyptian, of course, was then a stylish term, but by 1833 the firm then known as Blake, Garnett & Co. changed the name Egyptian to sans surryph, and then to grotesque. This last term was introduced by the English typefounder, William Thorowgood in 1832 and adopted by other English founders. Often shortened to "grot," it is still the standard term in Britain for the nineteenth-century sans serif types.

Following the quiet introduction of Caslon's Egyptian, there was no interest in the serifless letter in England until 1832, when three English foundries marketed sans serif types. These were produced in capital letters only, as was the Caslon font. A lowercase was not added until 1835 when Thorowgood cast a 7-line pica grotesque. In Germany, where there was widespread interest in the sans serif form, the Leipzig founder, J. G. Schelter, produced a sans serif series with lowercase about 1825.

In the United States, the first typefoundry to acknowledge the European experiments was the Boston Type and Stereotype Foundry which brought out a complete series and in a typical demonstration of American independence called it gothic. The at-

ABCDEFGHIJKLMNOPQRSTUVWXYZ
abcdefghijklmnopqrstuvwxyz

79. *Alternate Gothic*

tribution to blackletter can only be ascribed to the weight of the sans serif characters which did resemble the true gothic. Whatever the reason, the nineteenth-century sans serif are still referred to as gothics in the United States.

American printers' manuals of the last century rarely mention sans serif types. Thomas F. Adams' *Typographia* was first printed in 1828, and then in subsequent editions until it formed the basis of the most widely read manual of all, *The American Printer*, by Thomas MacKellar. Neither Adams nor MacKellar cites the American gothic types, although MacKellar's book went through eighteen editions from 1866 to 1893.

The gothics, or grotesques, remained popular throughout the nineteenth century. At its close they began new careers aided by a new concept in the sale of printing types—the "family"—made up of variations of an original design. In 1898, the German firm, Berthold, began cutting Akzidenz Grotesk, a family still available under that name and called Standard in the United States. The well-known Venus Family was introduced by Bauer Typefoundry in 1907. In the United States, Morris Benton began a design program of gothics in 1900 with Globe Gothic, followed by Alternate Gothic (figure 79) and Franklin Gothic (figure 80) in 1903, and News Gothic (figure 81) and Lightline Gothic in 1908. All except Globe Gothic remain standard in modern American printing.

Following the great sweep of popularity of the Cheltenham design about 1904–1911, the use of gothics declined. By 1930, after the initial impact of a group of European-founded geometric sans serif types, the term gothic was no longer synonymous with sans serif. They were not forgotten, however, even if after 1930 their use did indicate an apparent lack of typographic sophistication. In 1951, a trend began particularly utilizing Venus Extrabold Extended (figure 82). This revived gothic had such an impact in the

ABCDEFGHIJKLMNOPQ
abcdefghijklmnopqrstuv

80. Franklin Gothic

ABCDEFGHIJKLMNOPQRSTUVWXYZ
abcdefghijklmnopqrstuvwxyz

81. News Gothic

ABCDEFGHIJKLMNOPQ
abcdefghijklmnopqrstu

82. Venus Extrabold Extended

composition of advertising display that all gothics enjoyed a re-birth. The neophyte typographer now struggled to recognize Venus from Standard, and Alternate Gothic from Gothic Condensed No. 529.

It became apparent, however, that the old gothic type families were not complete enough for the typography of the Fifties. Weight changes were not subtle enough, certain weights lacked italics, and most important, the various weights and widths suffered from the lack of coherence in design. It seemed obvious that the newer additions to the family were not designed by the same hand as the older members.

Many typographers on both sides of the Atlantic considered these arguments valid. In Switzerland, the gothic form dominated the typographic scene in asymmetrical layouts which seemed rigid and clinical to many observers, but which neverthe-

less attracted a great deal of international attention. A young Swiss type designer named Adrian Frutiger, who had received a practical composing-room education before studying design, produced for the Paris foundry Deberny & Peignot, a new family of grotesques optimistically named Univers (see figure 83). This type was originally made for the Lumitype (Photon) phototypesetting machine and then manufactured in metal for the European market by Debeny & Pengnot.

Frutiger's method was to create at once a complete family of types (italics included) in all possible weights and widths required for any typographic purpose. He then proceeded to defy conventions which have plagued typographers for decades— completely inadequate nomenclature to describe type weights and widths. Frutiger created the Univers "pallette" in which he used a logical system of numbering the twenty-one variations of the Univers family. Basically this method assigns numbers in the 40's to describe the lightest weight, the 50's for medium, the 60's for bold, and the 70's for extrabold (figure 84). While this numbering system seems logical and necessary, it was poorly received by printers, who have gone to the trouble of assigning names to the numbers, thus perpetuating the chaos which Frutiger's method was designed to end.

Typefounders watched the typographers' approval of the concept of Univers with interest, and many followed the path of success. The Bauer foundry in Germany produced a gothic family called Folio (figure 85). The Stempel foundry, also in Germany, collaborated with the Swiss firm of Haas to produce Helvetica (figure 86), formerly called New Grotesk. All of these gothics are now widely used in the United States, and are available on various typesetting machines—hot metal, photographic, and strike-on. Other firms are also active with gothic families.

The style of letter introduced by William Caslon IV is therefore still used. Today in the United States, gothics are used less for continuous reading, as in books, but the type is still utilized for a great variety of printing and is virtually the type of our time. Typographic fashions change, but future printing historians will certainly be able to consider the 1950s and 1960s as the period of the international dominance of gothic type.

During the mid-1920s a convulsion in typographic taste occurred, and the results are still very evident. Artistic disapproval of the status quo sprang up in such European movements as

83. Sans serif: ATF Univers #65, designed by Adrian Frutiger as a complete family of types including twenty weights and configurations. These variations, designated by numbers rather than names, represent an attempt to give the family a completely logical nomenclature.

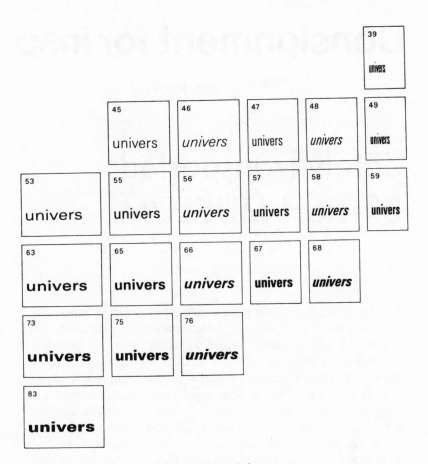

84. Univers Palette

ABCDEFGHIJKLMNOPQ
abcdefghijklmnopqrstuvw

85. Folio Medium

Consignment for insp

86. Helvetica Medium

Safely Transported
BRITISH MUSEUM

87. Futura Medium

Functionalism, Expressionism, Constructivism, and Cubism. These schools in turn attracted artists, architects, craftsmen, and designers who were disenchanted with their times. In 1919, the Bauhaus was established in Weimar, Germany, directed by architect Walter Gropius, whose programs fully recognized the need for artistic change. The Bauhaus was a technological school which understood the importance of innovation and regulated and guided the heretofore loosely organized movements.

The typography workshop instituted by the Bauhaus investigated many revolutionary techniques, including the design of a new alphabet by one of its instructors, Herbert Bayer. The Bayer design rejected the conventional capitals-lowercase sequence in favor of a font in which it was combined. This innovative, sans serif, alphabet departed from the everyday Fraktur of established German printing, and aptly expressed the Bauhaus idea.

Another German style was Futura, designed by Paul Renner, in 1927 (figures 87, 88). At first this type emulated some of the Bayer abstract formulas, but when taken in hand by the Bauer Typefoundry of Frankfurt, the oddities were removed, and the design became an immediate success. It was almost a complete monoline type, based on the geometric principles of compass and straightedge. Renner was doubtless influenced by the fine serifless alphabet produced for the London Underground in 1916 by the calligrapher Edward Johnston.

ABCDEFGHIJKL
MNOPQRSTUV
WXYZ&
abcdefghijklmn
opqrstuvwxyz
$1234567890

88. Futura Bold

PERHAPS THE FINEST
Perhaps the finest writing in

89. Kabel Bold

Ninety-seven Young Men
Run From Here to There

90. Metro Medium

The introduction of Futura type was also linked to the almost rigid asymmetrical typographical solutions of the Bauhaus itself. It is this combination which had such tremendous impact on the appearance of German printing.

During the same period, two other German type designers—Jakob Erbar and Rudolf Koch—were developing similar sans serif types. Erbar's type was completed first in 1924 but did not enjoy the enthusiastic reception later accorded Futura. The Koch letter, Kabel (figure 89), was produced simultaneously with Futura, and for several years competed very successfully with the Renner type. One of the most important twentieth-century German type designers, Koch provided traditional grotesque features for Kabel, particularly in the styling of lower case *a, e,* and *g*. American typefounders and manufacturers of composing machines soon issued sans serif types when the new style proved to be not simply an avant-garde innovation but a design which had the solid backing of typographers everywhere. From this belated recognition that the geometric sans serifs were going to be around for a long time, came several new types, hopefully to blunt the effectiveness of the great popularity of European designs.

American Type Founders Company (ATF) commissioned the German typographer and type designer, Lucian Bernhard, then

abcdefghijklmno
pqrstuvwxyz

91. Gill Sans 262

resident in the United States, to cut a sans serif in the new idiom. Curiously, this type received the name of Bernhard Gothic, although Futura had made the nineteenth-century gothics obsolete almost overnight. Mergenthaler Linotype Company requested a sans serif letter from William A. Dwiggins who had never before cut a typeface but was an outstanding calligrapher and typographic designer. The Dwiggins' type was named Metro (figure 90), The Intertype Corporation brought out Vogue, a new type definitely influenced by Futura, and the Ludlow Typograph Company produced a similar design in its Tempo series.

The Monotype firm did not compete in the race to produce a new geometric sans serif, but copied Rudolf Koch's Kabel instead. In 1929, the company commissioned the distinguished advertising type designer, Frederic W. Goudy, to draw a sans serif. Although Goudy has made his early reputation as a designer of advertising types, by 1929 he had lost interest in such styles and therefore did not put a great deal of effort into the Monotype commission. It has recently been revived, however, by ITC.

By 1930, there were many new sans serif types available to compete with Futura, but none of them—in the eyes of typographers—had the élan of the Renner letter. It soon became obvious to the American manufacturers that they had to meet the competition; they began to produce adaptations of Futura. While ATF and Mergenthaler combined to design Spartan, and Monotype produced Twentieth Century, Ludlow made no changes in the Tempo design. Intertype entered into an agreement with the Bauer Typefoundry to make Futura under a royalty arrangement.

In England, Eric Gill produced for the English Monotype firm a series of sans serifs named for him, which stemmed from the Edward Johnston Underground alphabet. (figure 91).

ABCDEFGHIJKLM
NOPQRSTUVWXYZ

abcdefghijklmn
opqrstuvwxyz&ff fi fl
$.,-:;!?'1234567890

92. Optima

A third style of sans serif type, neither gothic-grotesque nor geometric, is based on the humanist traditions of Renaissance letterforms. Contemporary type designers who have studied the proportions of the classic styles are always interested in the challenge of producing sans serif letters which are more legible and at the same time more beautiful than the skeleton forms previously mentioned. Stellar, designed in 1929 by R. Hunter Middleton for the Ludlow Typograph Company, is an example. The flared strokes of this type, coupled with their thick-thin contrast, present a real departure from the other models. One of the most popular types of the 1960s, Optima, designed by Hermann Zapf, is another example of a face which can retain classical proportions without serifs (figure 92). To summarize this account of the sans serif form, the classification may be informally subdivided into two groups—Traditional and Geometric—which cover the greatest number of forms. There are also many types without serifs which are so diverse in appearance they make adequate classification difficult. These include the classic-inspired Optima and Stellar along with such divergent styles as Lydian, Huxley Vertical, and Bernhard Fashion.

Script-Cursive

Possibly the most confusing single group of typefaces is script-cursive, or simply script or cursive. There has never been a satis-

ᴓᴀᴅvertising ᴾroficiency Explained

93. *Civilité*

factory basis for a more precise designation. While in general,
script types are patterned on handwriting styles, this does not
simplify the task of classifying them adequately. A further distinc-
tion is made by some typographers who list as script styles with
joining characters and as cursive those with separate characters.

The earliest cursive type was cut by Robert Granjon in France
about 1557 and was used to print a book of children's etiquette. It
was primarily a cursive of gothic origin and is known under vari-
ous names—in France, *lettre courante;* in England, the secretary
hand. As children's courtesy books were so frequently set in
models of this type, it became known as Civilité (figure 93).

With minor exceptions, the only important series of script
types—other than gothic inspired cursives—to appear before the
twentieth century are the typographic imitations of the copper-
plate engraving hands. As the nineteenth century witnessed the
tremendous growth of typefoundries catering to commercial
printers, numerous scripts appeared based on these free-flowing
letters with their great contrast of stroke, flourished decorative
capitals, and severely inclined angles. Most of these were
eighteenth-century copy-book hands, adopted from the writing
masters of a century earlier.

Some of the styles are English Round-hand, Spencerian, and
one of the more upright scripts, French Ronde (figure 94). By the
close of the nineteenth century, all founders offered such scripts.
Oddly enough, they were originally considered informal because
of their lack of resemblance to the more formally structured ro-
mans. Such types are now considered formal and are standard
for social printing, with its rigid criteria for correct usage.

Until the development of phototypesetting machines, the se-
vere angles of these scripts—along with their joining strokes—
gave typefoundries a virtual monopoly on their manufacture.
They must be cast on what is called a wing-body, in which each
character overlaps its neighbor. This limited the style to foundries
producing single types, and even these had to be cast so carefully
that the types were more expensive than standard fonts. The

$\mathcal{A} \; \mathcal{B} \; \mathcal{C} \; \mathcal{D} \; \mathcal{E} \; \mathcal{F} \; \mathcal{G} \; \mathcal{H}$

$\mathcal{I} \; \mathcal{J} \; \mathcal{K} \; \mathcal{L} \; \mathcal{M} \; \mathcal{N} \; \mathcal{O}$

$\mathcal{P} \; Qu \; \mathcal{R} \; \mathcal{S} \; \mathcal{T} \; \mathcal{U} \; \mathcal{V} \; \mathcal{W}$

$\mathcal{X} \; \mathcal{Y} \; \mathcal{Z}$

abcdefghijklmnopqrst

uvwxyzenort

1234567890

(&.,';:«»!?/-

94. *Rondo*

ABCDEFGHIJKLM
abcdefghijklmnopqrstuvwxyz

95. Typo Script

History Making Events

96. Bank Script

only slug-casting machine manufacturer that successfully adapted the formal scripts is the Ludlow Typograph Company, which produced the style on specially sloped matrices.

Probably the best known type in this category used in America today is Typo Script, first cut for ATF in 1903 by Morris Benton. (figure 95). A somewhat heavier version, Bank Script (figure 96), was issued during the Twenties, when formal scripts began to appear in advertising. Commercial Script, a boldface adaptation, was produced in 1906.

There are today a bewildering array of script types, yet almost none of them existed before 1930. The activity of the typefounders in the development of cursive designs stemmed from the great expansion in advertising typography in the mid-Twenties. The typographer's constant search for innovation first led to a wide use of hand-lettering. Naturally, the founders were prompted to bring out types imitating current styles of lettering to meet the demands of printers unable to afford a lettering artist but wishing to have contemporary scripts in national advertising. This function is today carried forward by the manufacturers of display lettering devices.

The new cursives were distinctly more informal than the Typo Script series and were generally pen- or brush-drawn. One of the earliest scripts to achieve international success was Holla, designed by the German type designer, Rudolf Koch. About the same time, the Signal series, another German type, was the first

The Yachting Club of

97. *Signal*

script to adapt to monotone sans serif types then beginning to dominate advertising (figure 97).

Trafton Script, one of the most widely used cursive types of the 1930s, followed Signal in 1933. As the demand increased, scripts were produced in great profusion and in numerous styles, until 1939 when World War II halted European imports.

For ten years after the war, scripts continued to be among the most popular output of foundries (figure 98). When well-designed and marketed astutely, they provided a lucrative income and enjoyed a brief but great popularity before declining to relative obscurity. Founders learned that advertising typography provided the first great surge of interest in a new script. After that they could expect small printers to keep the type active for several years.

The future of script types as a product of typefoundries now seems severely limited. Competition from process lettering firms, plus numerous devices which may be purchased to produce photolettering, have restricted founders in developing new designs in this genre. The high cost of marketing metal type requires a large sale of a great many fonts to obtain a reasonable profit. Photography, however, minimizes this cost and allows manufacturers of phototypesetting devices to offer a great many more styles at relatively little expense.

While scores of contemporary script types are presently available, it is doubtful that typefounders will remain interested in this market. It will be quite difficult to keep informed of photolettering scripts, because every manufacturer offers dozens of styles known only by number, many closely resembling one another.

It might help in classifying scripts, to place them in the following three loose categories:

1. **Calligraphic**—types derived from broad-pen;

2. **English Round-hand**—"formal" joining scripts;

3. **Brush scripts**—types formed with a brush rather than a pen.

Seven hundred Cambridge Economic

Virtuosa

ABCDEFG abcdefghijklmnopqrstuv

Lydian Cursive

After an Apprenticeship

Kauffman

All Knights of England

Brush

Maxime *Slogan*

London Script *Dynamic*

Parisian Ronde *Bon Aire*

98. *Examples of script-cursive types*

Decorative-Display

For over two centuries, printers have used specialized display types not always conforming to the letter structure of the historic faces that evolved since the fifteenth century. The embellishment of the printed page was originally the task of illuminators and rubricators serving scribes before the invention of printing. Soon printers experimented both with engraved initials, printed in one or two colors, and also with cast fleurons or ornaments, styled after bookbinders' stamps.

Thus, there has always been a desire to decorate pages of type, although in most instances during the era when the printing of books dominated the craft, such ornamentation was generally restricted to title pages, chapter headings, and tailpieces. At the close of the seventeenth century, the need to adorn the printed page to an even greater degree was apparent in the development of several fonts of decorated types. The earliest known type in this category was Union Pearl, an English design of calligraphic origin, cut about 1690. The matrices for this face survive, and the type may still be purchased from Stephenson Blake in the original 22-point size.

During the eighteenth century, many decorative types were cast. The Paris founder Pierre Simon Fournier produced a number of floriated alphabets and outline letters, as did the Enschedé foundry at Haarlem. Examples of both of these founders' work are still available. A study of these eighteenth-century types indicates that the emphasis was still directed toward printers of books, who sought esthetic adornment rather than strong commercial display.

The bookish approach reversed itself with the advent of the Industrial Revolution. Early in the nineteenth century English typefounders produced a variety of embellished types designed to emphasize their unique characteristics for the single purpose of attracting attention. Fat faces, grotesques, and Egyptians—decorative types when compared to the romans which had undergone but minor changes since the Italian fifteenth-century period— were not flamboyant enough for the new requirements of advertising display.

Founders soon discovered they could market practically any unusual design. During the first quarter century, the types issued were primarily inline or outline variants of the Didot-Bodoni

style, plus similar ornamentation of the Egyptian-grotesque types. By mid-century, however, competition among founders had resulted in a proliferation of styles too numerous to evaluate reasonably. Specimen books of the period bulge with scores of florid typefaces, admired today more as examples of the skill and imagination of the punchcutter's art than as printers' typefaces designed to communicate.

By 1860, the development of the electrolytic method of manufacturing matrices resulted in widespread pirating of designs in both Europe and the United States. While this simplified the founder's problems in meeting his competition, it unfortunately promoted badly designed types. And it also reduced employment opportunities for type designers with both esthetic judgment and imagination.

The excesses of nineteenth-century type design have undoubtedly engulfed the numerous good types issued during that period and they have caused the great bulk of display types to be thought of, deplorably, as simply "circus" types. By 1900 the private press movement brought renewed interest in types of classic origin. The decorative letter was consigned to the hell box until the 1920s, when once again for a very brief period it enjoyed a revival before succumbing to Bauhaus concepts of functional design.

Since World War II, the so-called Victorian types have been avidly collected as antiques. A few astute collectors capitalized on their investment during the Art Nouveau revival of the Sixties. As this interest continues, many nineteenth-century types have become available again through phototypesetting devices now widely used in composing rooms and in art studios.

Exact classification of the many types which can conceivably be listed as decorative is not easy. With such diversification of styles, memory is the typographer's most important ally if he is to become proficient in recognizing them. As with other listings in this classification system, many decorative faces fit reasonably into loose groups of similar characteristics. It will simplify matters to consider ordinary variations of standard letterforms as part of their original classification. An example might be Caslon Open or Goudy Handtooled (figure 99).

There are many inline or outline types that are independent designs and, although unadorned, may be properly classified as Decorative-Display. Such types are Columna (figure 100), a ma-

abcdefghijklmnopqr
ABCDEFGHIJKLM

99. Goudy Handtooled

juscule inspired by Roman inscriptional letters, and Trump Gra-
vur, a modern adaptation of the eighteenth-century Enschedé
type, Rosart. There are numerous other examples (see figures
101, 102). The novice typographer need not become involved in
hair-splitting about certain choices, except for the challenge of an
interesting argument. Possibly this last classification is the most
difficult to rationalize. For that reason I will remind the reader
once again that the primary purpose of a "system" is to get to
know types, so they can be put to use in the printed page.

Another group is ornamented types containing floriated pat-
terns within their strokes. Tuscans, with their baroque embellish-
ments, are the best examples of this style, but there are many
others with more restricted decorative elements. Shaded types
(figure 103) lend themselves to an informal grouping, although—
as in the outline letters—many are simple variants of standard
typefaces. Two other subdivisions are cameo types, in which let-
ters are reversed upon a solid or decorative background, and
stencil types (figures 104, 105).

A rationalization for placing a type in this last group might be
that it bears no basic relation to a normal well-constructed roman
letter. Ad Lib, for instance, is a type without serifs, but it is also a
bizarre form and therefore closer in spirit to Decorative-Display
than to Sans Serif.

Some typophiles list this entire category as the hell box; not
without reason, because it is here that those types are assigned
which cannot rationally be placed elsewhere. Of course, many of
the designs that turn up in this classification might better be rele-
gated to a real hell box.

100. Decorative-Display: Columna was originally produced as a private type for a Swiss publishing firm. Its design is based on the roman letter found on the Trajan column and gives the impression of being an incised letter. It is cut only in capitals and figures.

BROWN FOX

101. Old Dutch

FOX JUMPS

102. Lexington

THE QUICK BROWN FOX

103. Old Bowery

OVER THE LAZY

104. Futura Black

THE BROWN FOX

105. Stencil

Sources of Printing Types

Digital fonts

Adobe Systems, Inc., Post Office Box 7900, Mountain View, California 94039

Bitstream, Inc., Athenaeum House, 215 First Street, Cambridge, Massachusetts 02142

Linecasting matrices

Linotype AG, 425 Oser Avenue, Hauppauge, New York 11788

Marlboro Mats, Box 188, East Shore Road, Coolin, Idaho 83281

SOS Linotype, 2920 Sidco Drive, Nashville, Tennessee 37204

Metal type fonts

Acme Type Foundry, 1720 North Marshfield, Chicago, Illinois 60622

American Printing Equipment & Supply Co., 42–25 Ninth Street, Long Island City, New York 11101

Barco Type Founders, 237 South Evergreen Avenue, Bensenville, Illinois 60106

Bell Type & Rule Co., 1128 East 11th Street, Los Angeles, California 90021

Fundicion Tipografica Neufville, S.A., Travesera de Gracia 183, Barcelona-12, SPAIN

Haas Typefoundry Ltd., 1 Gutenberg Road, CH-4142, Munchenstein, SWITZERLAND

Harold Berliner's Typefoundry, 224 Main Street, Nevada City, California 95959

Johannes Wagner Foundry, Postfach 227, 49A Theodor-Heuss-Strasse, D-8070 Ingolstadt, FEDERAL REPUBLIC OF GERMANY

Kingsley/ATF Type Corporation, 200 Elmora Avenue, Elizabeth, New Jersey 07207

Los Angeles Type Founders, Inc., 13255 East Imperial Highway, Whittier, California 90605

Ludwig & Mayer GmbH &Co., Postfach 114, D-6052 Mühlheim, FEDERAL REPUBLIC OF GERMANY

Mackenzie-Harris Corporation, 460 Bryant Street, San Francisco, California 94107

Mould Type Foundry Ltd., Dunkirk Lane, Leyton, Preston PR5 3BY, ENGLAND

Quaker City Type, R.R. 3, Box 134, Honey Brook, Pennsylvania 19344

Stephenson Blake (Holdings) Ltd., Sheaf Works, Maltravers Street, Sheffield S4 7YL, ENGLAND

Typefounders of Chicago, Inc., 3649 West Chase Avenue, Chicago, Illinois 60076

Phototypesetting equipment and fonts

Agfa Compugraphic Corp., Type Division, 200 Ballardvale Street, Wilmington, Massachusetts 01887

Alphatype, 506 West Campus Drive, Arlington Heights, Illinois 60004

AM International, 333 West Wacker Drive, Chicago, Illinois 60606

Autologic, 1050 Rancho Conejo Blvd., Newbury Park, California 91320

Berthold Corporation, 2 Pennsylvania Plaza, New York, New York 10121

Hell Graphic Systems, 25 Harbor Park Drive, Port Washington, New York 11050

Itek Graphix Composition Systems Division, 34 Cellu Drive, Nashua, New Hampshire 03063

Linotype AG, 425 Oser Avenue, Hauppauge, New York 11788

Monotype Typography, 600 West Cummings Park, Suite 1800, Woburn, Massachusetts 01801

Varityper, 11 Mount Pleasant Avenue, East Hanover, New Jersey 07936